NEW JERSEY WOMEN
IN
WORLD WAR II

PATRICIA CHAPPINE

THE
History
PRESS

Published by The History Press
Charleston, SC 29403
www.historypress.net

First published 2015

Manufactured in the United States

ISBN 978.1.62619.821.0

Library of Congress Control Number: 2015934344

Notice: The information in this book is true and complete to the best of our knowledge. It is offered without guarantee on the part of the author or The History Press. The author and The History Press disclaim all liability in connection with the use of this book.

CONTENTS

ACKNOWLEDGEMENTS

I would like to thank several people for their support throughout this project. For helping me with my research: Douglas Atkins at the U.S. National Library of Medicine; Joseph G. Bilby, from the National Guard Militia Museum of New Jersey, who gave me a generous amount of help; Skip Bellino and the wonderful staff at the Atlantic County Historical Society; Felice Ciccione at the Gateway National Recreation Area; Lisa Jester at the Millville Army Airfield Museum; Hillary Kativa at the Chemical Heritage Foundation; Woody Kelly, who runs an informative site about the women of the British Air Transport Auxiliary (http://www.airtransportaux.com/); Beth Koelsch at the Betty H. Carter Women Veterans Historical Project at the University of North Carolina–Greensboro; Sue Koller at the Navy Lakehurst Historical Society; Marston Mischlich, who took the time to discuss my topic with me and offered me many helpful suggestions; Heather Perez at the Atlantic City Free Public Library; and Dianne Wood at the Wheaton Arts Center in Millville. Thanks go to the following organizations for allowing access to their records: the Library of Congress, the National Archives and Records Administration, the Naval Historical Foundation, the Rutgers Oral History Archives and the University of North Carolina– Greensboro. Special thanks to Dr. Carol Rittner for inspiring me to go on to graduate school and pursue a career in teaching. I appreciate all the help and encouragement you have offered throughout the years.

I had the distinct privilege of interviewing several amazing people who were involved in the war effort in New Jersey. I want to thank Pat Witt for

ACKNOWLEDGEMENTS

inviting me into her home, sharing her stories and photographs with me and showing me the amazing Barn Studio of Art, which she founded in 1962. (For more information on this, please visit http://www.barnstudio. org.) Thanks go to Bee Haydu for allowing me to interview her about her time as a WASP. I am also grateful to Nicholas Rakoncza, who spoke with me about his time in the service and his parents, who both worked in the defense industry during World War II. Also, thanks to Whitney Landis at The History Press for supporting this project, working with me and answering any questions I had during this process. And thanks to Julia Turner at The History Press for all her work in editing this book.

I want to thank my husband, Ernie, for putting up with me as I spent a great deal of time doing research and writing for this project. I appreciate all the support from my parents, Anthony and Patty, and my sister, Toni. And of course, thanks to my best friend Kasi Comunale, who has been putting up with me since kindergarten.

INTRODUCTION

Nicknamed Black Tuesday, the Wall Street crash of 1929 signified the beginning of a decade-long Great Depression. Like the rest of the nation, the New Jersey of the 1930s was a place of uncertainty and economic strife. Unemployed men roamed from town to town in a last-ditch effort to find work. Desperate people stood in bread lines that flowed down sidewalks and meandered around street corners. While men struggled to support their families, women were forced to make do with what they had. It was during this time that First Lady Eleanor Roosevelt called on the women of the nation to help drag America out of the economic crisis. In 1933, she wrote, "The women know that life must go on and that the needs of life must be met and it is their courage and determination which, time and again, have pulled us through worse crises than the present one." From reusing old clothes to buying day-old items, American women used ingenuity to ensure that their families were cared for. These habits served them well in dealing with the shortages brought on by the nation's entrance into World War II.

With the German invasion of Poland on September 1, 1939, the stage for war was set. Two days later, Britain and France formally declared war on Germany, starting World War II. With the spark of hostilities in Europe, the world was on edge. How far would this conflict spread? Who would be affected? The United States kept a watchful eye on the unfolding events. Although America sent supplies to Britain early in the conflict, the overwhelming public sentiment was that of isolationism. With the Great Depression still looming over their heads, many Americans were more

worried about their personal problems than the escalating war in Europe. This mood changed drastically with the Japanese attack on Pearl Harbor on December 7, 1941. When asked if people expected that the United States would join the war, Pearl Patterson Thompson said, "Oh, yes, we knew it was coming in the [spring of] the final year there...the tension was so strong you could really feel it. Everybody was excited and, yet, tense, because the boys were getting their draft numbers." The anticipation of what would come once the United States finally entered the conflict weighed heavily on the minds of many.

The tragic events at the United States naval base in Oahu, Hawaii, galvanized public support for American involvement in the war. Glued to their radios like the rest of America, New Jersey residents anxiously listened to the news. Before the attack, the nation was divided between the isolationists who wanted to stay out of the war in Europe and the interventionists who wanted to add America's military to the fray. After Pearl Harbor, public opinion swayed overwhelmingly in support of American intervention. Young men scrambled to volunteer for service. The next day, President Franklin Delano Roosevelt addressed Congress asking for a declaration of war on Japan. In his "Day of Infamy speech," Roosevelt vowed:

> *Japan has therefore undertaken a surprise offensive extending throughout the Pacific area. The facts of yesterday and today speak for themselves. The people of the United States have already formed their opinions and well understand the implications to the very life and safety of our nation. As Commander-in-Chief of the Army and Navy I have directed that all measures be taken for our defense, that always will our whole nation remember the character of the onslaught against us. No matter how long it may take us to overcome this premeditated invasion, the American people, in their righteous might, will win through to absolute victory.*

In preparation for war mobilization, President Roosevelt approved the Selective Service and Training Act on September 16, 1940. Passed by Congress ten days later, this act required all men between the ages of twenty-one and thirty-six to register for military service. According to Roosevelt:

> *After thoughtful deliberation, and as the first step, our young men will come from the factories and the fields, the cities and the towns, to enroll their names on registration day. On that eventful day my generation will salute their generation...May we all strengthen our resolve to hold high the torch*

of freedom in this darkening world so that our children and their children may not be robbed of their rightful inheritance.

The next crucial step was to fervently increase war production. The United States prepared for complete mobilization in support of the war effort. The Allies needed planes, weapons, tanks and much more. With the desperation of joblessness during the Great Depression fresh in their minds, citizens welcomed the opportunities that the defense industry created.

During World War II, the need for the women of the United States to step into roles long closed off to them set off an unprecedented wave of participation. American women jumped into virtually every aspect of the war effort, from selling war bonds to serving in female branches of the armed forces. There truly was a job for everyone. Women joined the defense industry, welding and riveting alongside men. They volunteered for the Red Cross, setting up field hospitals and aiding the injured. They canned food, faced rationing with creativity, made their own clothes and knitted socks to send to the troops overseas. They collected paper to make plasma boxes for blood drives. With an ever-present eye on military morale, they visited injured soldiers, played games with them and provided home-cooked meals. For many, it was considered a patriotic duty to support the war effort in some way. Since many of the men were fighting overseas, they needed the support of the homefront. Women of all ages joined the effort in varying degrees. Some volunteered for multiple initiatives; others went from full-time jobs during the day to volunteering at night or on the weekends. Still others joined the newly created female branches of the armed forces. Whatever the case, the women of New Jersey mobilized for war like the rest of the nation.

The war permeated virtually every area of society. It touched people's lives in personal ways. June McCormick Moon recalled being a child during the war years. She said, "There was no television, so we listened to the radio a lot. Every half-hour there was a war bulletin, and then after that, serials with war themes." New Jersey newspapers were saturated with war-related content. Rationing and canning advice was given. Local members of the armed forces were reported on. Sometimes the reports contained boastful pieces about promotions or medals, and other times the articles were grim, reporting the sacrifices made by local men. Columns on growing successful Victory Gardens littered the pages. Calls for volunteers for the Red Cross, the USO or the Salvation Army were advertised. Often, a stern image of Uncle Sam implored the reader to buy war bonds. Heartfelt advertisements warned about the dangers of wasting materials. Articles reminded citizens

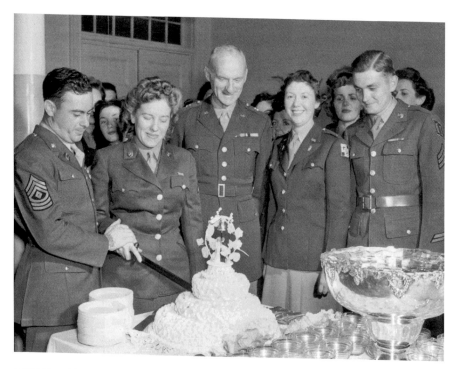

A WAC and her new husband cut the cake at a wedding celebration, 1943. *NPS/Gateway NRA Museum Collection.*

about blood drives, wartime job openings and scrap metal and paper collections. The activities of women in the military were also reported, from new enlistments in the WAC and other units to promotional announcements. Toys reflected the growing preoccupation with war. Young boys and girls were seen playing with army doctor and nurse kits. Even comic books published wartime storylines.

New Jersey faced unique challenges by virtue of its vast shoreline—130 miles of coastline was a blessing in times of peace and a concern in times of war. With German U-boats lurking in the vast waters of the Atlantic Ocean, danger was constant. This looming menace led to ominous dim-outs up and down the shoreline. White sand beaches, previously host to bathing suit–clad families and lazy summer fun, were virtually deserted. Blackout curtains replaced open windows. For the citizens of New Jersey and those in other states, World War II represented a turning point deeply embedded into their memory. The sheer number of men who left for war changed the makeup of society. The brothers, sons, husbands, fathers, cousins and uncles of the Garden State left for the European or Pacific theaters en masse. The

loved ones they left behind kept busy in an effort to bring them home as soon as possible. Eventually, the world made the slow creep back to some kind of normalcy. However, the tragedies and triumphs endured by those involved stayed with them for a lifetime.

While the participation of women on a national level was truly impressive, each state also faced unique challenges and triumphs. The women of New Jersey were no exception. Through impressive networks of local and statewide participation, groups and individuals in the Garden State were actively involved in war mobilization. Their wartime record, both on the homefront and abroad, is truly inspirational. This book is the story of those women who selflessly and tirelessly dedicated their time to supporting the war effort in various ways. In a society with few opportunities for women outside the home, these local heroines stepped out of their comfort zones, some for the first time, and walked into many traditionally male jobs. Others used their familiar status as caregivers to expand their roles into the public arena by keeping up the morale of the troops in the USO or the American Red Cross. Many of these stories have yet to be told in detail. The impressive record of the women of New Jersey during World War II is a testament to their spirit of local responsibility and national pride.

1

ON THE HOMEFRONT IN NEW JERSEY

The only thing needed for us to win the European war in 1944 is for every man and woman from the frontline to the remotest hamlet…to do his or her full duty.
—*General Dwight D. Eisenhower*

Every conflict is different. The weapons, reasons and aggressors of war change with time. One of the most unique features of World War II was the mobilization of the homefront. Not long after America joined the fray, the mood in New Jersey shifted. The threat of German U-boats in the Atlantic Ocean led to dim-out restrictions all along the Atlantic coast. Since New Jersey has such a vast area of shoreline, a large portion of the state was affected. The huge storefronts, bright casinos and once bustling nightlife made Atlantic City a prime target for attack. Realizing the high visibility of the resort town, the military was especially concerned with implementing dim-out regulations. Drills were a way to ensure that, in the event of a real emergency, residents could quickly extinguish their lights. During these exercises, like the rest of the coast, sirens sounded and Atlantic City was plunged into darkness. Residents used heavy blackout curtains and painted cardboard, wood and other materials to serve as effective barriers against any escaping light. An ominous darkness blanketed the once bustling resort community. The bright lights of the casinos that had once created the impression of an artificial daytime were gone. Navy vessels observed the shoreline from the ocean and reported any glaring exceptions. These

precautions were believed to make it difficult for German U-boats to find targets for attack.

Local police officers patrolled the streets looking for violations and issuing citations when necessary. While the drills occurred periodically throughout the war, dim-out regulations for many shore communities were in place nightly. In a notice to residents and visitors of Atlantic City, the locality informed everyone that the only lights to be used on main streets and thoroughfares were low-intensity blue lights. Absolutely no neon lights were allowed. The wattage on all other lights could not surpass 150. Any windows visible from the ocean had to be covered in shades approved by the Atlantic City Electrical Bureau. Any windows not facing the ocean were still shaded or covered in a thick curtain to stop any escaping light. Vehicles moving at night were permitted only the use of parking lights or regular lights painted half black.

Subsequent drills followed throughout the war. One such drill, held throughout the entire state of New Jersey, occurred in June 1942 to practice in case of a real emergency. In Atlantic City, the drill was lauded as a success. Once the warning sounded, residents of the city were to turn off all lights and plunge the streets into complete darkness. During the blackout, lights flashed and sirens blared from the Atlantic City Electric Company, firehouses and other locations. Suddenly, storefront windows disappeared, streetlamps went out and vehicle headlights were switched off. Within minutes, a menacing darkness overtook the city. Only a few homes disobeyed. Wardens patrolling the streets took notice and reported the violations to local police. Excepting those few instances, the only lights that remained visible were the Coast Guard station and city hall. Citizens waited eagerly for the all clear to be announced on the radio.

Pat Witt, who grew up in Millville, New Jersey, recalled the shore dim-outs. She said:

> It was very frightening here during World War II. People don't realize it because we're so near the coast. So we were in black out time and all the headlights of the cars were painted black half way down, streetlights were capped and low, very low. We had black out curtains up at the window...They had air raid wardens and if they saw a crack of light they would come to your door and you could get fined. They didn't want you to strike any matches.

As the war continued, some restrictions were lifted while others remained in effect until the end of the conflict.

Jean Comeforo recalled the uneasiness of the air raid drills. She said, "I remember everything went out in an air raid. All the street lights went out. Everything was pitch black, you better put out all your lights, you should have had dark shades over your windows already anyway, but you better put out the lights in your house."

Residents of shore communities were not the only New Jersey citizens who noticed wartime changes. The war touched everyone in some way. Virginia Boardman said:

> *I mean, you can't believe the whole country was involved. I mean, it wasn't like Vietnam or any of these other wars we had since…but the whole country was involved, because if you weren't in the war, you were either doing nursing, like we were, or working in a factory…Rosie the Riveter, that kind of thing, you know. I mean, everybody was involved.*

Along with a feeling of togetherness, the war also bred apprehension and suspicion. People, especially those involved in defense industry work, were urged not to talk openly about anything concerning the war effort for fear that spies and saboteurs lurked on the homefront. Campaigns against "loose lips" created an air of secrecy. The localities of New Jersey prepared for an enemy attack at home by forming civil defense councils that met to create action plans in case of an emergency. These councils also organized training for volunteers who wanted to respond to a disaster or crisis. New Jersey citizens volunteered to be on the police reserve, women joined police auxiliaries, locals served on rationing boards and volunteers aided rescue squads.

It seemed as if the threat of an enemy attack was always present. Many New Jersey women volunteered to be vigilant in their spare time. According to Pat Witt:

> *My mother became an airplane spotter…The women were trained to identify any plane that would go over. They would have four hour shifts these women. My mother was a school teacher and she was a volunteer to do this. If there was an enemy or any kind of suspicion, the phone lines went right to the air field. We were a defense! She could identify by sound, what kind of plane it was.*

Air raid wardens stood at the ready to alert citizens of an attack. Joan Yunker Higgins, born in Montclair, New Jersey, recalled her mother's time

as an air raid warden. "Well, first of all, she always had a hard hat, and she had to patrol, patrol the block and be sure that everybody had their shades down, no light would appear." She said, "You know Montclair was only eighteen miles from the ocean, you see, and so anything on the whole East Coast had to be dimmed out so that they couldn't spot you." Some places even organized mock attacks to imitate an emergency response. In Freehold, New Jersey, a simulated Axis invasion that garnered the attention of the local press was held. In May 1942, planes flew over the area, dropping leaflets to represent enemies parachuting in for an attack. Soldiers prepared to defend their homes and local law enforcement arrested actors playing German saboteurs. For three hours, Freehold held these mock activities to prepare for a real invasion that luckily never happened.

Simulated events such as this were the result of very real fears in wartime society. What would New Jersey citizens do if the enemy attacked the shore? Who would respond to an air raid? What if one of the civil defense factories was targeted? The citizens and political officials of the Garden State faced all of these questions and more. With the country in an indefinite state of emergency, the responsibility for New Jersey's preparedness rested on the shoulders of city governments and local politicians. Not long after the war was officially on, defense councils sprang up throughout the state. No council tackled the issue of preparedness in precisely the same way. The difference in population, proximity to the shoreline or military bases and other factors influenced what was considered a priority in different places. Some areas focused more on the medical response, organizing casualty stations staffed with doctors, nurses and volunteers. Others geared up for attack by adding volunteers to their fire departments. Civil defense was a blanket term that applied to various activities designed to ensure homefront readiness in the event of an emergency. Factory work, scrap collection, donating blood and buying war bonds all contributed to the war effort. These new concerns also changed the society of wartime New Jersey. People could not escape the fact that there was a war on. From small inconveniences like reusing clothes to life-changing events like losing a loved one in combat, the residents of New Jersey were forever changed by the war.

The Neptune City Local Defense Council was quite busy with preparedness activities during the war years. The volunteers of this small locality engaged in dim-out enforcement, a salvage committee, victory gardens and writing monthly letters to military men. It organized local women to join a police auxiliary. A Demolition, Rescue and Repair Squad formed to fix water supplies, clear debris, perform structural repairs, demolish buildings that were damaged

beyond repair and fix gas leaks. Air Raid Wardens stood at the ready in case of an attack. The Emergency Medical Service, or First Aid Unit, was needed to provide medical attention to residents. In the event that all radio and phone lines were disabled, the Communications Section of the Defense Council formed a Messenger Corps that prepared people to act as runners to physically transport messages back and forth. Drills conducted with these young male volunteers proved how efficient this delivery method was. Female volunteers worked with the Red Cross to collect clothing, make kits and gather money.

Mothers on the homefront felt the effects of the war in rationing restrictions and gas shortages. Mary Lou Norton Busch recalled:

> *The whole world became upside down…I mean, you've probably heard these stories, but you couldn't get any* [goods]. *They stopped manufacturing consumer goods. It all went to the war effort and, I mean, you couldn't even get clothes. You had not the choice of clothes. When Bill and I got married, we couldn't get any stuff for the house, sheets, towels…Everybody gave us things from their house when we got married, because there just wasn't any goods…There was no gasoline. We were rationed on gas.*

Because a significant amount of material was needed for the war effort, women reused and reconditioned old clothes. With the Japanese attacks in the Pacific theater, many areas that were supplying the American market with rubber for tires were compromised. This caused the U.S. government to impose restrictions on tires and measures geared at conserving the rubber already in use. A thirty-five-mile-per-hour speed limit was one such attempt. Gas was rationed based on the fact that if people had less gasoline then they would wear their tires down at a slower rate. Mothers were encouraged to can food from their victory gardens instead of relying on produce from the grocery store. Beginning with the rationing of sugar in May 1942, other food rations were introduced more and more as the war dragged on. Popular items like coffee and red meat soon followed. The pressure was on to not waste anything and to get by with an ever-growing list of shortages. The Office of Price Administration created a complicated color-coded system of rationing for women to follow when shopping. The stress on mothers was so great that many local New Jersey newspapers published advice columns or advertisements on how to pack lunches. In 1942, a Red Bank newspaper read:

> *If you are one of the "kitchen soldiers" packing lunch boxes for war workers, you can make a big contribution to production efficiency by making*

sure each on-the-job meal is well-balanced, nourishing and appetizing. Lack of proper nutrition is the greatest enemy of efficient war production, particularly in crowded areas where inadequate eating facilities encourage sandwich grabbing.

Other women spent their spare time wrapping bandages or collecting scrap metal and paper for the war effort.

Military bases, such as Camp Kilmer, Fort Monmouth and Fort Hancock, were scattered throughout the state. The sight of uniformed men performing drills or just traveling about was common. While more men donned military uniforms, the absence of young men was felt everywhere. The rush to join the war effort after Pearl Harbor caused a hole in New Jersey society. College campuses emptied and the activities of the college students left changed drastically. Social gatherings centered on local USO clubs and other volunteer opportunities. Even without officially joining an organization, college women in the Garden State went to nearby hospitals and USO clubs to visit the soldiers and keep their spirits up. Catherine Ballantine spoke of the shift in the atmosphere at Douglas College, a women's college established as part of Rutgers University. She said, "They started up what they called 'war courses' which were voluntary, we didn't get any credit for those. The one I signed up for, Leadership in Recreation…We did different trips to Fort Dix and to Kilmer." For many, college credits were sacrificed in order to hone skills that were deemed essential in wartime. Thousands of New Jersey women flocked to military branches just now accepting them because of the severe shortage of fighting men.

Japanese Americans, mostly from the West Coast, were relocated to internment camps across the country. At Seabrook Farms in Cumberland County, New Jersey, the wartime labor shortage led to the use of Japanese Americans who were interned in those camps. Ruth Sheeler Moncrief of Bridgeton, New Jersey, taught students from Seabrook. She recalled, "They had successful businesses out there and families and nice homes, and some of them were sent to Seabrook Farms. We had a very rural community. Cumberland County was very rural. Seabrook Farms was big into frozen foods and everything else, so they built little cottages to house these people." The fear that Japanese Americans would turn against the United States proved entirely unfounded.

With many large industries in operation before the war, it was no surprise that many of the Garden State's factories converted to wartime production. Women flocked to industrial jobs at large companies like Johnson and

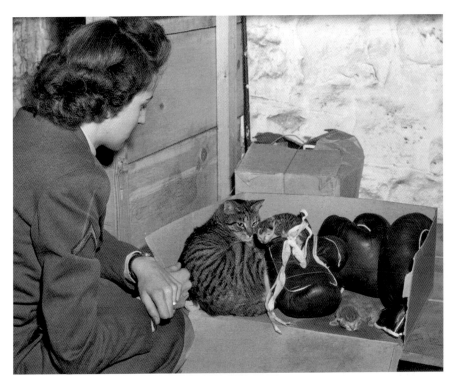

A WAC at Fort Hancock looks after a cat and her kittens. *NPS/Gateway NRA Museum Collection.*

Johnson, Singer Sewing Machine Manufacturing Company and the Eastern Aircraft Division of General Motors. They learned jobs deemed too difficult for them. They were welders, mechanics, riveters and so much more. The youth were affected, as well. Colleges changed some of their course offerings to hone skills that might be needed in wartime. The military often used campuses for recruitment or training. The Girl Scouts and Boy Scouts, among other youth organizations, were involved in collecting scraps, procuring blood donor pledges, selling war bonds and more.

Hospitals converted to handle a large influx of injured soldiers. The women of the Red Cross made sure that these facilities were stocked with bandages and staffed with caring hostesses for recovering soldiers. When funds were absent, these women collected donations and, in some cases, gave their own furniture or recreational items to keep patients occupied. At Tilton General Hospital in Fort Dix, New Jersey, Red Cross volunteers set up a recreation program for injured military men that included arts and

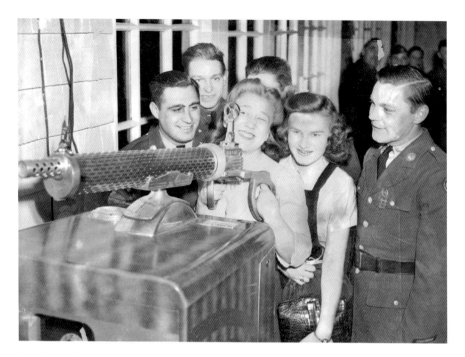

New Jersey National Guardsmen at Fort Dix show off a machine gun, December 1940.
Joseph G. Bilby.

crafts, films and card games. During Christmas, hostesses filled stockings for the servicemen. Countless other organizations helped in both small and large ways during the war. The Ladies Garment Workers Union of South Jersey donated furniture for the common areas of the Tilton Hospital so the soldiers could have a comfortable place to socialize or write letters.

An often overlooked part of wartime society was dealing with the absence of men in both families and society as a whole. Women were suddenly living without their husbands; children were without their fathers, and in some cases, mothers saw their sons go off to war. The absence of men was a kind of double-edged sword. On the one hand, women lived with rationing, gas shortages, financial hardships and the constant fear of tragedy. On the other hand, the absence of a large portion of men gave women more freedom. They were in charge of the household, and in many cases, they were now the breadwinners. One woman described the hardship of being at home during the war as follows: "At first you feel abandoned and you feel angry because they took him when you needed him at home. Then you turn around and you feel proud because he was not afraid to go." The emptying of once bustling

college communities was another side effect of wartime on the homefront. Jean Comeforo, who went to college in New Brunswick, said, "The fellows got drafted from Rutgers, and so the social life just disappeared really, and the other thing was that it was a...very serious time. This was wartime and our fiancées and our boyfriends and our uncles and brothers were going... overseas, and we were frightened for all of them." Some of her classmates made a ritual of making daily trips to the library to read the casualty lists printed in the newspaper. They anxiously scanned the text, looking for any familiar names and hoping to find none.

With many women doing their part on the homefront, fear for loved ones in combat was always on their minds. In a letter to her mother, Bee Haydu, who was completing WASP training at the time, wrote with concern about her brother. "I pray every night for Lloyd. Most of the girls down here who have fellows in the service have not heard from them in some time." Through all the difficulties of living on the homefront during World War II, the women of New Jersey responded with ingenuity, patriotism and determination.

2
JOINING THE FIGHT

THE WOMEN'S ARMY CORPS

Life in the armed services is hard and uncomfortable, but I think women can stand up under that type of living just as well as men.
—Eleanor Roosevelt

When the time comes that women are needed in the fighting line, they will be found in the fighting line. They are evidently needed in Russia and they are doing what it is necessary for them to do. In the pioneer days of our own country, many a woman fought side by side with her husband; and if the need comes again, women will meet that need.
—Eleanor Roosevelt

In the America of the 1940s, the idea of women joining the army was unfamiliar and a little alarming. In a society where a woman's place was generally in the home, the role reversals caused by American involvement in World War II were unimaginable and often met with skepticism or hostility. As with the recruitment of women in defense industry jobs, the U.S. government began to look more favorably on women joining auxiliaries of the armed forces after the Japanese attack on Pearl Harbor. With the massive number of soldiers needed on the front lines, it seemed only logical that women would be trained to fill clerical and administrative positions, thereby freeing up more men for combat. General George C. Marshall, army chief of staff during World War II, believed that the war would eventually warrant the use of women in the armed forces. During this time, the U.S. Army became the earliest

A WAC works at Fort Hancock. *NPS/Gateway NRA Museum Collection.*

military branch to introduce women into its ranks, first in auxiliary forces and then as enlisted members.

On December 30, 1941, Massachusetts congresswoman Edith Nourse Rogers introduced a bill to establish the Women's Army Corps. The bill called for the creation of "a Women's Army Auxiliary Corps for non-combat service with the Army of the United States for the purpose of making available to the national defense when needed the knowledge, skill, and special training of the women of this nation." In the past, women had served as nurses for the Army but were not officially recognized as veterans. Thus, they did not receive any protections or benefits from the government. Rogers wanted to make sure that this did not happen again. In the male dominated society of America in the 1940s, it was not surprising that her bill was met with fierce political resistance. However, with the support of the War Department, the bill was finally approved on May 14, 1942. It was signed by President Roosevelt the following day with these thoughts:

I do hereby establish a Women's Army Auxiliary Corps for noncombatant service with the Army of the United States for the purpose of further making

WAC greetings at Fort Hancock. *NPS/Gateway NRA Museum Collection.*

> *available to the national defense the knowledge, skill, and special training of the women of this Nation; and do hereby authorize and direct the Secretary of War, as a first step in the organization of such Corps, to establish units thereof, of such character as he may determine to be necessary to meet the requirements of the Army, with the number of such units not to exceed 100 and the total enrollment not to exceed 25,000.*

However, Congress expressed in no uncertain terms that women were not to be placed in active combat. Despite this restriction, recruitment for the WAAC commenced. The corps took Pallas Athena, Greek goddess of wisdom, courage and war, among other things, as its symbol.

Under the leadership of Oveta Culp Hobby, the official director of the WAAC, the first trainees arrived at Fort Des Moines, Iowa, on July 20, 1942. Since Hobby was the first leader of the WAAC, the group was sometimes referred to as "Hobby's Army." Eventually, the WAAC became the WAC as the "auxiliary" part was dropped. In January 1943, Congresswoman

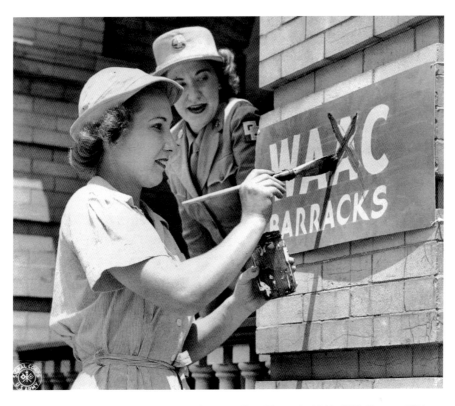

A WAC paints the second *A* off a WAAC sign at Fort Hancock, 1943. *NPS/Gateway NRA Museum Collection.*

Rogers introduced another bill to both congressional houses. This time, she asked that women be formally commissioned in the U.S. Army. Roosevelt had approved this measure by July 1, 1943, officially creating the Women's Army Corps (WAC). Upon hearing that President Roosevelt signed the bill dropping the "auxiliary" part and officially creating the WAC, Colonel Joseph Haw, the commander of Fort Hancock issued the following statement:

> *I am glad to learn that President Roosevelt has signed the bill. Fort Hancock's WAC detachment arrived just a short time ago and has not yet reached full strength, but in the short time they have been here the personnel of the corps already have demonstrated how effectively they can serve as adjuncts to the compliment of this post. The duties the WACs have been assigned to here are being performed efficiently, and members of the corps have shown a keen sense of responsibility toward their jobs.*

A post commander at Fort Monmouth echoed this sentiment when he said, "Our WACs are filling many important jobs on the Post. They have replaced men in clerical and desk jobs. They are driving trucks and jeeps; they are working as hospital technicians and attendants…We could use twice their present number if we could only get them." A commanding officer of the WAC detachment at Fort Monmouth declared, "I think that the girls are glad to know that they really belong now." The recruits gave up a great deal to serve their country. Carol Levine said, "We gave up everything we had. Some had more, some had less, but I had a comfortable house. I had a fairly decent job. But I gave it up because I thought it would help the war effort." With many young men giving up their health and their lives to fight the Axis powers, women on the homefront were eager to show their support by giving up as much as they could.

The WAC bill authorized 150,000 women to serve in the WAC during World War II. They provided vital support to the war effort throughout the conflict. They stand out as the first women, other than army nurses, to work within the U.S. Army in an officially sanctioned capacity. These women faced unique challenges. Their existence within the army was a mixed blessing at times. Simply being the first women incorporated into the military, they faced the uncertainty of new training regimens and more than a little hostility from certain members of the military and society as a whole. Some argued that, with women entering into military service, the family would be threatened. Who would keep American homes running if the women were away? Who would care for the children on the homefront? Would these military women look and act like men? These and other fears caused some women to pause when considering service. However, thousands of women put aside these criticisms and joined anyway. Many young women went against their parents to join. Others, who did not need their parents' permission, enlisted in secrecy to avoid conflict with other relatives and in some cases their own husbands. Breaking gender boundaries has never been an easy task. The responsibility of setting an example and paving the way for future generations of young women who wanted to serve their country weighed heavily on these pioneers. The pressure from those who wanted to see them fail was also an ever-present shadow. Director Hobby recognized this early on:

You do not come into a Corps with an established tradition. You must make your own. But in making your own, you do have one tradition—the integrity of all the brave American women of all time who have loved their country…Your performance will set the standards of the Corps. You will

live in the spotlight. Even though the lamps of experience are dim, few if any mistakes will be permitted you.

Captain Mary A. Hallaran also realized the magnitude of the task ahead for these women in the Women's Army Corps. After demobilization, when the question of a permanent place within the army was still being debated, she wrote the following to her fellow WACs:

You have been over the hurdles once—back in the WAAC/WAC days. There were many bets against you then: that you couldn't take it…Those who bet against you lost. You sold the country on the value of women in a wartime Army. You sold the Army on the need for women in the peacetime establishment…Breaking the trail has always been harder than following it.

Like any other military branch, WAC enlistees had to meet certain criteria before being accepted. Women between the ages of twenty and forty-five with no dependents under age fourteen were eligible for recruitment. Successful candidates also needed to complete the following steps: the Army General Classification Test, a background check, a reference check, have completed at least two years of high school and meet certain physical standards. By January 1943, in an effort to recruit even more women, these original requirements were relaxed. Hobby was against the lowered standards. By April of that year, the original standards were reinstituted. Basic training for new recruits included drills and courses in map reading, military customs and first aid. Officers received additional training in leadership, administration and court-martial procedures. Once they passed basic training requirements, WACs could be assigned to any number of duties and locations while in service. They served as radio operators, control tower operators, photographers, stenographers, cryptologists, telephone operators and much more. After the initial recruitment success of the Des Moines training facility, more training centers were opened in Florida, Georgia, Louisiana and Massachusetts.

In August 1944, Camp Kilmer hosted a recruitment event for the WAC. Despite a reported several hundred enlisted army women already in residence at the camp, the drive was dedicated to finding many more to fill different positions. According to Lieutenant Katherine Wagner of Absecon, director of WAC recruitment at Camp Kilmer:

Many women feel that they want to become members of the Army, but they are reluctant about leaving their homes. Perhaps their husbands or

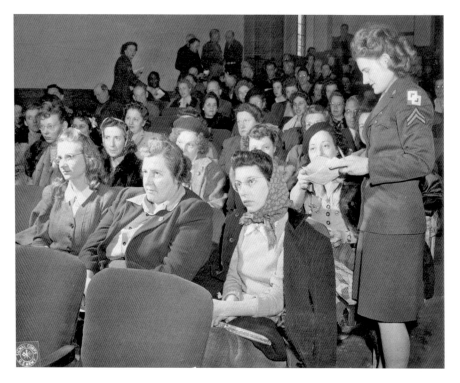

A WAC hands out programs at Fort Hancock. *NPS/Gateway NRA Museum Collection.*

loved ones are in military service, and there is a possibility that they will be coming home on leave and they want to be there to greet them. Or perhaps a woman's husband is still home engaged in some vital war work and she wants to be close to him. These and a dozen other personal reasons have kept many women from wearing the Army uniform. But now women may enlist in the Women's Army Corps and be sent, upon their request, to nearby Camp Kilmer and may also select the job they wish to perform.

Women who signed up for WAC service went through basic training that included military discipline, regimentation and physical training. For some new recruits, this was the first time they had ever left home. After completing basic, WACs could be assigned anywhere on the homefront, in the European theater or in the Pacific. The sheer number of different types of work possible for recruits was staggering. A sampling of the many jobs open to WAC recruits was as follows: motion picture projectionists, chauffeurs, recruiters, administrators, stenographers, drivers, typists, statistical clerks, stock record clerks, photographers, hospital orderlies,

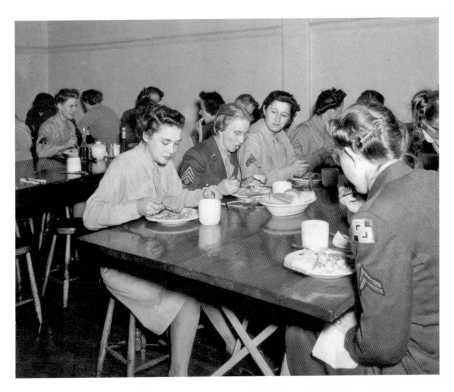

WACs eating at a mess hall at Fort Hancock in 1943. *NPS/Gateway NRA Museum Collection.*

tailors, auto service mechanics, rifle repairmen, laboratory technicians, financial clerks, supply clerks and officers. For women who faced limited opportunities before the war, these new possibilities were amazing. Some lucky recruits enjoyed the support of their families. Carol Levine said, "All my relatives wrote to me. They were so proud that they had a 'soldier girl' in the family."

Mary Robinson, of Rockaway, New Jersey, was a reporter in the WAC. She remembered her time in the army fondly. She said, "No, I just thought it was a sensible thing to do. The British had done it in two wars…Women were taking on the jobs everywhere else doing everything men had done before being drafted. It just didn't seem to be much of a departure." She trained at Fort De Moines, Iowa, and then went on her first assignment at Camp Robinson in North Little Rock, Arkansas. In some cases, WACs learned several diverse skills and performed vastly different jobs during their assignments. For instance, Mary's first job was as a medical aid at Camp Robinson. She spent some time on duty in the Pacific theater.

NEW JERSEY WOMEN IN WORLD WAR II

WACs from New Jersey did not help only the Garden State during the war. While some were stationed locally, others were scattered throughout the United States after their training. For some young women, the draw of service was the opportunity to see other parts of the United States and, in some cases, areas in the European or Pacific theaters, as well. Olga Lewandowski Lathrop served in the WAC from 1944 to 1946. The child of two Polish immigrants, she grew up in Newark, New Jersey. With such close family ties to the events unfolding in Europe, Olga was eager to join the war effort. As soon as she was old enough to enlist, she started her WAC training in Fort Oglethorpe, Georgia. She worked as a lab technician during her service.

Kathryn Fulner Wakefield, of Hillsdale, New Jersey, served in the WAC from 1943 to 1945. By the time she graduated from high school in 1939, there was a pretty clear indication that the hostilities in Europe would extend to United States involvement. Her first job after high school was as an office worker for a leather tannery in New York City. On her way to work, even before the United States joined the war, Kathryn recalled walking by posters and signs urging people to join the war effort. She was moved by the advertisements: "All those signs were pointing at me, 'We want you. We want you.'" She quickly made up her mind that she wanted a more intimate involvement in the war effort. "And I said, 'Oh, that looks interesting. That's just what I want to do.' So, secretly I always kept looking in the paper, looking for where I'd like to go in the service. I didn't want to tell my family I was even interested." Anticipating resistance from her mother, she signed up for the WAC without telling anyone. As she suspected, her mother was less than enthusiastic about her daughter joining the military. When Kathryn announced that she was enlisting in the WAC at the dinner table, her mother cried. Without much agreement from home, she left for basic training anyway. She was stationed at the army air base in Greenwood, Mississippi, and then at a base in Jackson, Mississippi. Her work involved administration, stenography and recruiting.

Kathryn had a positive experience working with the men on the bases. On her birthday, the soldiers went all out to make her feel like part of their extended military family. She reminisced: "But what was so nice about the men, they just loved us. For some reason, they just took to the WACs, because we were in uniform and everything. And so when they heard I had a birthday on the twenty-ninth of that [month], they said, 'We're going to have a birthday party. You can invite anyone you want.' That was so nice.

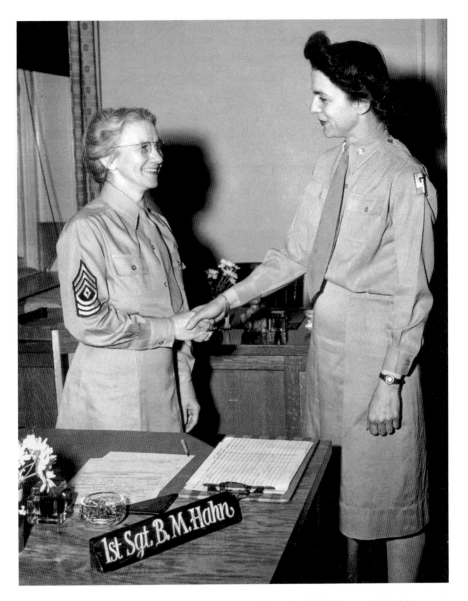

First Sergeant B.M. Hahn greets a WAC at Fort Hancock. *NPS/Gateway NRA Museum Collection.*

But they had a nice big cake and everything. They treated us so nice. On the twenty-ninth I was twenty-four."

In fact, this was not an uncommon occurrence. As with anything else, WACs had different experiences throughout the war. Some recalled

nothing but respect and acceptance while others have stories on the opposite end of the spectrum. Some WACs enjoyed the unyielding support of their friends and family while others faced such opposition that they had to enlist in secret.

THE WACs JOIN CAMP BOARDWALK

During the Second World War, the resort town of Atlantic City was transformed into a hub of military activity. With gas shortages and rationing threatening to hit the economy of the city, local politicians welcomed the military into the area. In June 1942, Army Air Force Basic Training Center 7 set up shop in Atlantic City. Major hotels began to convert their hospitality rooms to barracks. The Ambassador Hotel held the distinction of being the first one converted for military use. Others soon followed, including big names like the Claridge, the Madison, the Ritz-Carlton and the Traymore. All told, over forty hotels in the area were utilized for the military, earning Atlantic City the wartime nickname Camp Boardwalk. The hotel transformations were truly remarkable. Extra furniture was placed in storage to make room for more practical office furniture and equipment. Formerly extravagant guestrooms designed for away-from-home comfort were outfitted with military bunk beds. Some hotels were used as hospitals for injured soldiers sent back to the homefront to recover. Throngs of beachgoers with their bathing suits and blankets were replaced by khaki-clad soldiers. Families walking the boardwalk were replaced by rows of soldiers doing drills in front of Convention Hall. "The World's Playground" was now Camp Boardwalk. Convention Hall was converted into the headquarters of the Army Air Forces Technical Training Command. The massive Thomas M. England General Hospital was converted for wartime use. In the summer of 1942, there was hardly a doubt that the United States armed forces had moved in to Atlantic City.

Opposite, top: Atlantic City residents watch seemingly endless rows of Army Air Corps servicemen as they march by the corner of Pennsylvania and Atlantic Avenues. *Atlantic City Free Public Library.*

Opposite, bottom: A look at swearing-in ceremonies for the Women's Army Corps. (Assistant city clerk Peggy Speas is pictured fifth from the left). *Atlantic City Free Public Library.*

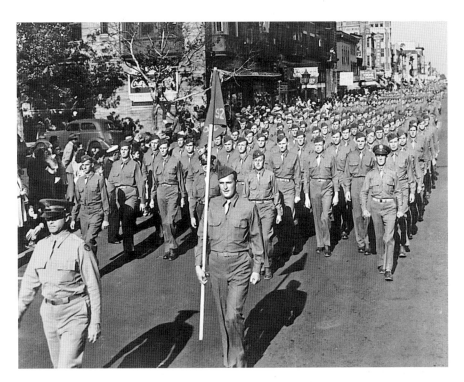

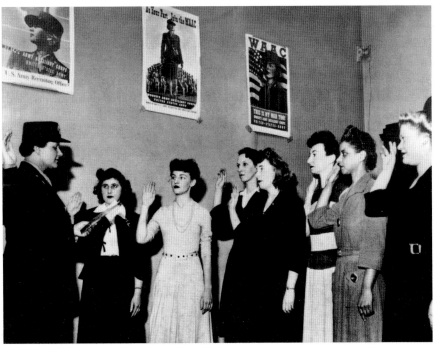

Of course, not every Atlantic City resident was thrilled about the conversion. Some, including local business owners, were concerned about what affect the army occupation would have on tourism. Others were worried about the changes that the influx of young recruits would cause. To quell the concerns of the locals, the Atlantic City Board of Trade issued the following statement in an August 1942 pamphlet: "Although thousands of Soldiers, Sailors, Coastguardsmen and the 'DIM-OUT' are here for the duration, Atlantic City is still the city by the sea where health, pleasure and recreation become a reality for all visitors." Tourists were still welcome at the resort community; however, wartime concerns, gas rationing and other obligations kept attendance to a minimum.

The atmosphere of the hotels was not the only wartime change witnessed in Atlantic City. With the increase in soldiers, the women who volunteered to support them became a more prominent presence, as well. The women of the American Women's Voluntary Services (AWVS) were often seen loudly parading up and down the boardwalk in their neatly kept uniforms. USO hostesses and Red Cross volunteers became a welcome sight for the troops. An observer often saw the women of the WAC or the SPAR performing drills in front of Convention Hall.

WACS ELSEWHERE IN NEW JERSEY

WACs were stationed at various points throughout New Jersey. A local woman from Somers Point, Mary Somers McArdle wrote about her time as a WAC. "I wanted to do something for my country, but I was shy and bashful and was nervous about being on my own. After I got in the service, I quickly got over that and soon could speak to anyone." Independence was certainly a useful result of being away from home at military bases throughout the United States. Once the officials in the army saw the usefulness of women taking over for military men, the call for more WAC recruits increased dramatically. In Red Bank, New Jersey, the local paper reported a drive to recruit over two thousand women for WAC service in November 1943. The drive was part of an all-states recruiting campaign for which quotas were assigned to each state based on the number of battlefield casualties. Lieutenant Margaret Clarke, head of the Red Bank recruitment efforts stated:

Our offensive in this war must be sustained. To do this we must send thousands of replacements to the battlefronts and keep supply lines moving. Women can take over many vital Army jobs and thereby release able-bodied men for combat duty. Recently the War Department disclosed that our Army casualties have totaled over 70,000. The Women's Army Corps is appealing to all eligible, patriotic women to replace those men. We need one WAC from New Jersey for each of the 2,212 casualties….Now that we are in a total war, affecting the total population, men and women must work together once more toward another victory.

Clarke went on to talk about the physical requirements of recruits. She said, "Since the demands of war are numerous and varied, each WAC must be ready to take her place alongside our fighting men despite long hours and tedious work. If she is not fit, she will fall by the wayside." For the many women recruits, the pressure to succeed was daunting.

Of course, many in society refused to accept these new roles for women. Rumors about immorality within the WAC spread during the war years. These unfounded stories were so prolific that even First Lady Eleanor Roosevelt felt compelled to comment on the situation in her *Ladies' Home Journal* column "If You Ask Me." Roosevelt wrote, "These girls have stricter supervision than any other group of girls in the country, and they are serious-minded young women who have volunteered for a war job. This rumor about immorality went the rounds in Great Britain and in Canada when women started to replace men, and it looks to me very much like Axis-inspired propaganda." Some young women were discouraged from joining the WAC because of these malicious rumors. However, this did not stop tens of thousands of women from joining anyway.

Despite this public backlash against women in the military, within months of the creation of the WAC, other women's branches followed suit, including the WAVES of the navy, the WASPs of the air force, the SPARs of the Coast Guard and the Women's Marine Corps Reserve. The stellar service of women won the support of many high-ranking officials, including Dwight D. Eisenhower and Douglas MacArthur. These women in the military helped pave the way for the future involvement of generations of American women. In 1948, Congress passed the Women's Armed Services Integration Act, granting women permanent status in the regular and reserve units of the U.S. Army, navy, air force and marines.

The call for WACs to work with the air force was advertised throughout New Jersey. The air force sought WACs qualified to train in any of the

following positions: supervisor or administrative aide, clerk, typist, machine operator, mechanic, maintenance, radio and telephone operator, driver, cabinet-maker, medical aide and more. WAC riggers packed, patched and inspected parachutes for U.S. paratroopers. They staffed dental clinics inside camp hospitals. They worked in kitchens at the bases, serving mess halls full of military men and women. The jobs of a WAC were varied and essential to the war effort.

Fort Monmouth, located in central New Jersey, also became a hub of WAC activity during World War II. The manpower shortage caused by men being deployed to combat areas caused an urgent need for WAC replacements at the base. The first women to be trained there were twenty-six WAC officers in December 1943. Soon after, WACs were sought to work in the Signal Office, performing jobs such as accountant, medical assistant, supply worker, clerk, editor, photographer and darkroom worker. Often, WACs arrived in groups with only twenty-four hours' notice. A WAC supply officer stationed at Fort Monmouth commented, "It's a big job getting things ready for these large groups, but in the army we must be prepared for sudden readjustments. No matter how hopeless the task seems at first, everything suddenly begins running smoothly again, and even I am surprised at the amount of work we accomplish on such short notice." Sometimes women were put in jobs according to their former civilian jobs or educational experience. A commanding officer of the WAC detachment at Fort Monmouth stated, "A former factory worker may find that the Women's Army Corps can use her as a radio operator. On the other hand a laboratory technician in civilian life may continue in the same work as a member of the WAC, and a newspaper reporter might be placed in public relations." Of course, some women found themselves in jobs completely out of their area of knowledge.

Lieutenant Clarke cited the many opportunities women could be afforded after the war because of the specialized training they received as WACs. She said, "Women who receive technical training in the army will find themselves in a fortunate position professionally after this war is over. More important than that, they will be seeing to it that the war is over sooner." A WAC laboratory technician from Red Bank said, "The biggest thrill in my whole life was seeing my first dress parade of WACs at Fort Oglethorpe, and knowing that I was, in a small way, connected with them. I think the WAC is one of the finest organizations ever." Many women spoke of the sense of belonging fostered by WAC membership. The WACs of New Jersey formed surrogate families in their training and duty stations.

Whenever an area faced a deficit of workers, members of the WAC were called in to help. For instance, to combat the increasing wartime shortage of nurses, WACs were recruited at army hospitals, as well. In response to the manpower deficit in vital medical positions, George C. Marshall announced in January 1945 that a new recruitment drive for the Women's Army Corps Medical Units would commence. In a letter concerning this situation, Marshall wrote to governors and commissioners throughout the country:

The care of the increasing number of casualties returning to the United States, together with the acute shortage in nurses and hospital personnel generally, necessitates urgent measures being taken to recruit and rapidly train women for service in Army hospitals. We urgently need WAC units for our 60 general hospitals. Your leadership in recruiting these women will be of great service to the army.

Fort Hancock, in Sandy Hook, New Jersey, a barrier peninsula in Monmouth County, became a key center for military activity during World War II. Its location in New York Harbor made it an important defense point. Surprisingly, the area's military activity dates back to the War of 1812, with the fort officially named in 1895. The first WACs arrived at Fort Hancock in the early summer of 1943. Mostly involved in support positions at Fort Hancock, they worked in clerical and administrative positions, drove motor pools, worked in the dental office and staffed the Post Library. The women's barracks (Barrack 25) were separated from the men's. According to military regulations, the barracks of the men and women needed to be placed a minimum of 150 feet apart or have a structure in between. Barrack 25 included double wooden beds and lockers for the recruits.

Of course, not every woman who helped the homefront efforts was actually from New Jersey. WACs could be sent anywhere across the country and overseas after they completed basic training. Mary Duff Heckendorn, who was born in Maryland, was a member of the WAC sent to work at Fort Hancock after training. While there, she worked at the Post Library and wrote a column for the *Sandy Hook Foghorn* (Fort Hancock's newspaper). Another out-of-state WAC was Loretta Reilly Hoffman. A native of Brooklyn, New York, she was stationed at Fort Hancock in 1944. When asked why she joined the WAC, she stated, quite matter-of-factly, "There was a war on. If I had been a man I would have been in." She completed basic training at Fort Oglethorpe in Georgia. Fort Hancock was her first assignment. "It was exciting. I got away from home. You know, my father was very strict. I lived

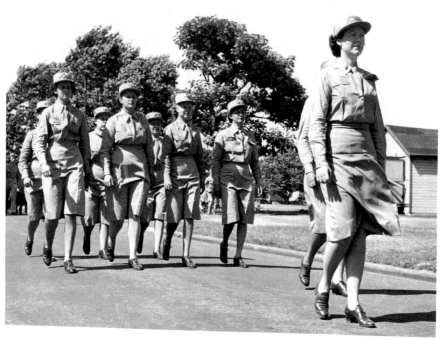

WACs marching at Fort Hancock. *NPS/Gateway NRA Museum Collection.*

in Brooklyn, New York. I wasn't allowed to go into Manhattan except to go to work." About adjusting to military life, she said, "It was really just like any other day. You get up and you have your breakfast and we had exercises in the morning. And you go to work and you have lunch and you go back to work and you are finished at the end of the day, at five o'clock." Mary fondly recalled her time at Fort Hancock. "For me it was a wonderful experience. I was sent down there from Madison Barracks, New York at (Sackets Harbor) Watertown…And it was spring and a nice job in the library and all together it was really pleasant. If I hadn't had my heart set on going overseas I would have gladly stayed there."

While each woman's motivation for joining the WAC varied greatly, many common themes emerged. Some wanted to see more of the world and gain some independence from their parents; some simply viewed it as their patriotic responsibility as an American citizen. Others viewed it as an adventure, and still others thought that they could help end the war more quickly and bring their loved ones home. Whatever the individual motivation to join, local WAC involvement was extensive. Ida Perlmutter

Kamich, born in New York City in 1916, enlisted in the WAC after already being a civilian employee at Fort Dix. Her family moved to South River, New Jersey, about two years after her birth. With an eye toward a career in healthcare, Ida decided to enroll at Douglass College to study dietary sciences. She successfully completed her program in 1938. After graduation, she worked at the Trenton State Hospital. Soon afterward, she went to Fort Dix to work as a dietician and joined the WAC to continue her job there. In 1942, she was sent to the Thirtieth General Hospital in England. By the time the war ended, she had earned the rank of second lieutenant in the WAC.

By the time victory in Europe was declared, the number of enlisted WACs was over 99,300. Social opposition to women in the service, along with other issues, stopped the WAC from achieving the recruitment goal of 150,000. This shortage caused some, most notably Colonel Hobby, to favor a draft for women. This never materialized. With the hostilities finally over, the U.S. War Department officially stopped recruitment for the WAC on August 29, 1945. In July 1945, Hobby had resigned because of family obligations and recommended Westray Battle Boyce as her successor. Colonel Boyce was tasked with disbanding the WAC. As with anything else involving a large number of people, demobilization was a process. Similar to the dismissal of the military men, the women of the WAC were dismissed from duty according to their ASR (Advanced Service Rating) score. Members of the WAC required less points than enlisted men to be eligible for discharge.

Even with their commendable record, it seemed that the WAC was being left behind in postwar plans. At the close of the war, there were no plans to continue the WAC. Some members were disappointed to say the least. Colonel Anna W. Wilson expressed her disapproval at the annual conference of WAC officers and directors in September 1945. Looking out over a sea of eager faces, Wilson said, "One of the things that bothers those of us returning from overseas is the realization that so many Americans have decided that we are through and it is time to pack up and go home." Ever hopeful, she continued on, saying, "We are the medium through which the knowledge and experience gained in the utilization of womanpower during this war can be preserved. We are also a nucleus, a framework around which total mobilization of woman power can be effected in the next emergency." On February 5, 1946, Eisenhower, newly promoted to chief of staff, was given the responsibility of drafting legislation to include the WAC in the U.S. Army and establish a Reserve Corps.

In 1948, debates on the implementation of an amended version of the Women's Armed Services Integration Act began. A contingent of

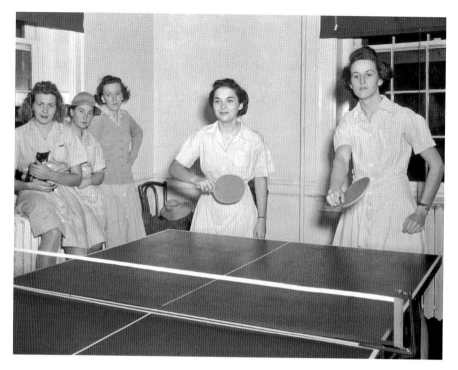

WACs play Ping-Pong at a recreation area at Fort Hancock, 1943. *NPS/Gateway NRA Museum Collection.*

House representatives seemed determined to block the bill. Still a staunch proponent of the value of military women, Eisenhower said, "I think it is a mistake to put [the women] on a Reserve basis rather than a Regular. I think they should be an integrated regular part of the Army. I think the Air Forces feel the same way. We need them." Despite the glowing endorsement of Eisenhower and several others, the debate raged on. Finally, on June 12, 1948, President Harry S. Truman signed the Women's Armed Services Integration Act into law.

Despite the bets against them, the service record of the WAC was truly remarkable. WAC members received honors such as the Purple Heart, the Bronze Star and the Prestigious Service Medal. Many military leaders who actually worked with WACs during the war praised their service. Many skeptics were converted by the wartime record of WAC members. In one of the most compelling postwar endorsements, General Dwight D. Eisenhower, who was formerly one such skeptic, said, "During the time I have had WACs under my command they have met every test and task assigned to

them…Their contributions in efficiency, skill, spirit, and determination are immeasurable." General MacArthur referred to the WACs as "my best soldiers." Lieutenant General Ira C. Eaker voiced his opinion that the WAC "be retained as part of the postwar military plans." The hard-won acceptance of military men was but one victory for the WAC. These women paved the way for the inclusion of women in the military today. After World War II, women continued to serve in subsequent conflicts, fighting for equality every step of the way.

WAVES, SPAR AND MARINES

In their first year, the WAVES have proved that they are capable of accepting the highest responsibility in the service of their country.
—*Franklin D. Roosevelt*

The need for more manpower was not only a civil defense industry issue. Beginning with the U.S. Army and moving to other branches of the military, women entered into various roles to free up men for active duty on the frontlines. The navy accepted women into its ranks shortly after the WAC bill became official. On July 30, 1942, Roosevelt signed the Navy Women's Reserve Act, establishing the Women Accepted for Volunteer Emergency Service, or the WAVES. These women were not set up as auxiliaries of the military as the WAAC had been. Rather, they were officially members of the navy. However, these women were not allowed to go overseas for service. An estimated eighty-six thousand women volunteered for the WAVES during World War II. The enlistment requirements for WAVES were decidedly different from those of the WACs. WAVES were required to have a college degree or a combination of at least two years of college coupled with professional experience. They needed to be physically fit and be at least twenty-one. As with other women's branches, both enlistment requirements and some training changed during the course of the war. Basic training lasted for six weeks. Like the women of the WAC, WAVES enlistees learned basic military practices and drills. For many of these young women, leaving for basic training was their first time away from home.

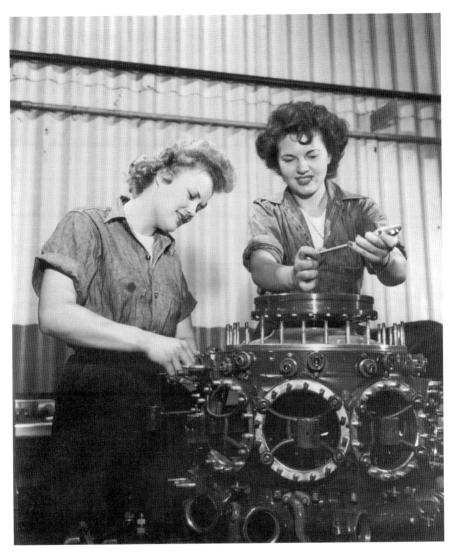

Members of the WAVES study aircraft mechanics at the Naval Air Station in Lakehurst, New Jersey. Pictured are Seaman Second Class Elaine Olsen (left) and Seaman Second Class Ted Snow. *U.S. Navy Photograph, National Archives.*

Many colleges and universities allowed the use of their campuses for training. For instance, New Jersey recruits went to Hunter College in the Bronx, New York, for basic training. The first WAVES officers were women who already held professional civilian careers. In fact, the first director of the WAVES, Mildred Helen McAfee Horton, left a career in

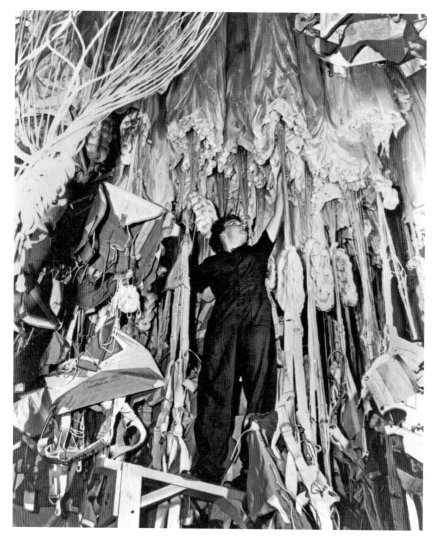

A WAVES member works as a parachute rigger. *U.S. Navy Photograph, National Archives.*

higher education as the president of Wellesley College in Massachusetts. WAVES jobs included aviation machinist's mate, metal smiths, parachute riggers, aerographers (weather experts), link trainer operators and repair positions. They worked in hospitals and base libraries. The jobs a recruit in the WAVES could expect were numerous and varied.

WAVES trained and worked at the Naval Air Station in Lakehurst, New Jersey. The station is most well known for being the site of the Hindenburg

crash on May 6, 1937. Now combined with other stations under the name Joint Base McGuire-Dix-Lakehurst, the Lakehurst Station has a long and vital history in the Garden State. Both Lakehurst and Camp Dix were formed in 1917. Previously called Camp Kendrick, the Lakehurst Station was originally used as an ordnance testing area for the army. Camp Dix was utilized as a training and staging area for the military during World War I. In 1919, the navy began building Hangar One at Camp Kendrick. In 1921, the navy purchased the site from the army and renamed it Naval Air Station Lakehurst. The station continued to expand after that, adding thousands of acres to its original site. The location of the site made Lakehurst strategically important as a homefront defense.

Fort Dix was named an official army installation on March 8, 1939. During this time, the base included a massive thirty-five thousand acres of New Jersey farmland and woods. Once World War II was over, around 1.2 million soldiers passed through the installation before returning home.

The importance of the WAVES was not lost on President Roosevelt. On July 30, 1943, the first anniversary of the WAVES, he proudly announced:

One year ago today the United States Navy opened to this Nation's patriotic womanhood an opportunity for service within its ranks. The wholly voluntary response came in such swelling volume as to constitute a ringing confirmation of the tenet that, in total war, democracy must be fought for and defended by all the people. Once again, the women of this free land stepped forward to prove themselves worthy descendants of those proud pioneer daughters who first nurtured freedom's flame.

Nancy Petersen Godfrey of Clark, New Jersey, was stationed at the Wildwood Naval Air Station during the war. For those who knew Nancy, being a WAVE was not a surprising choice. She took an early interest in anything that had to do with the navy. In her youth, she was so enthralled by books about people who sailed around the world, that her bedroom was complete with ship wallpaper and bedding. Once she was aware of a WAVES recruiting drive, she made her way to a station in New York City to enlist. Nancy reported to basic training at Hunter College in New York City. Despite her love of anything naval, she had a sense of being in over her head when she started basic. She described her induction: "But I remember thinking that I had made a terrible mistake. This is the first day. Oh, but, I volunteered so, well, tough it out…Well, you know, how it is, you always have doubts about things that are new." Like many other

recruits suddenly thrown into this unfamiliar setting, Nancy was resolved to continue on.

So, why did women join the WAVES? According to Nancy, "I would guess it was mostly something new to do and, you know, you mix that in. I mean, this was a just war and it was the thing to do and all the men were going, and if you felt that we should participate equally, it was the chance to

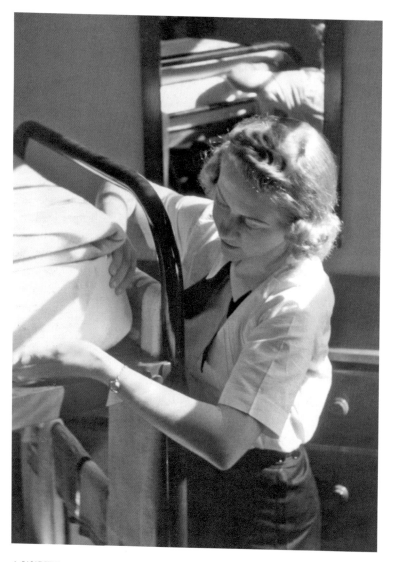

A WAVES member makes sure the corner of her bunk is up to navy standards. *Naval Historical Foundation.*

look heroic, or something." Job training was another plus. In most cases, an enlistee picked a job preference. Nancy's first choice was control tower operator and her second was link trainer. However, every enlisted woman was not lucky enough to be placed where she wanted.

Boot camp lasted several weeks and was used to indoctrinate the new recruits with navy discipline. They learned to make beds to military standards and pass the quarter bounce test.

Although the barracks were separate, Nancy recalled eating together with the men in the same mess hall. For recreation, the New Jersey shore was a favorite destination. There were WAVES at Cape May and Lakehurst.

A typical day consisted of a regular regimen that included reporting to work. During downtime, they played card games, read or wrote to loved ones. Sometimes, they watched movies or organized small parties at the base. However, both the men and women had to be ready in case of an emergency. Occasionally, Nancy recalled, there were accidental crashes on the base. In such events, the personnel had to be ready to respond in case of injury or fire.

Pearl Paterson Thompson, born in Irvington, New Jersey, moved to Union, New Jersey, at the age of five. She studied journalism at Douglass College and eventually set her sights on a navy career. Wartime involvement was a family affair for Pearl. Her father served in World War I and was a consultant during World War II, and her mother volunteered with the Red Cross during World War II. She remembered, "The entire family went to work. I viewed it as, 'my house is on fire,' I have to help put out the fire. There were people, men, who thought that it was unladylike, and didn't quite agree that this was a good idea. They weren't ready yet to accept this equality notion." The atmosphere at Douglass promoted involvement, as well. Additional course offerings during the war included Red Cross classes on tourniquets and bandaging and other essential first aid. When Pearl saw the state of those enrolled in the mechanics courses, she quickly decided on another option. She said, "I took one look at all that dirty gunk under the hood and decided I would join the Navy." Because of her experience in Europe, she worked for the Office of Naval Intelligence in Washington, D.C., after her training.

Jean O'Grady Sheehan, who grew up in New Brunswick, New Jersey, joined the WAVES in 1943. She was sworn in at a recruiting station in Lower Manhattan. For Jean, her decision to join was the result of many converging reasons:

You didn't really know how long it was going to go on, because, in 1943, there was still a lot of fighting to come, as it turned out, and you

did feel very patriotic, but there were other issues besides the patriotism. There was a selfish issue there, the traveling, the being away from home, getting away from home, the wearing the nice uniform. At age twenty, that was a big appeal. Yes, it was exciting for a young woman.

Her training included information on navy policies, ships, aircraft and laws. After she completed basic, she was involved in recruitment efforts.

WAVES served in much-needed positions at hospitals, as well. Margaret Harriet Waugh, who spent her youth in Newark, New Jersey, was a Hospital Corps worker during the war. She completed her training at Hunter College. Margaret described the timed nature of everything in training, even the chow line: "We had eighteen minutes to eat it all. It was timed because they had so many people to feed in such and such a time, and the food had to be kept hot." Because she chose to go into the Hospital Corps, she was trained to perform those duties after basic training. They were taught to bandage injuries properly, mostly practicing on each other. To learn to give shots correctly, they practiced on oranges. She reported for duty in Brooklyn, New York. Her tasks at the hospital were varied. On any given day, she would help to move a patient from their bed, give baths, reapply bandages, deliver medicine, change beds, polish the floors or clean the bathrooms. The overnight shifts consisted of work such as sterilization and providing anything the patients needed at the moment. "There was no slack time…every, you know minute of your time was accounted for, pretty much…there were things you had to do or…somebody to take care of."

As a WAVE, Rosemarie Spagnola Dodd of Ohio was an aircraft mechanic at Mercer Field in Trenton, New Jersey. When asked about her motivation for joining the navy, she simply said, "I thought, 'Well, heck, this is our war too,' and so I wanted to go into the service. Well, I went down to join the Marines, and the young man there told me that I wasn't big enough to join the Marines, because I only weighed ninety-six pounds." Undeterred, she decided to apply to the WAVES instead. After her acceptance, she trained at Hunter College. She recalled her training in military discipline, marching and identifying ships and aircraft. For Rosemarie, the Saturday morning full dress review always stood out in her memory. "You know, we were right in the middle of a neighborhood, because it used to be Hunter College, and they had all these big buildings, you know, with apartments," she said. "People would get up on the roof and hang out the windows to watch us every Saturday morning pass in review."

After completing basic, Rosemarie was not one of the women working in a clerical job. Instead, she was trained in the maintenance and repair of aircraft. She checked the brakes, fixed landing gear and inspected

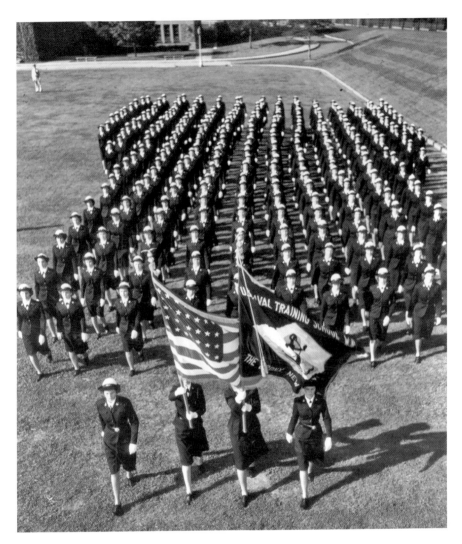

Navy WAVES marching in New York. *U.S. Navy Photograph, National Archives.*

the guns, among other responsibilities. One of the most physically challenging tasks was engine work. Rosemarie learned to remove, disassemble, reassemble and then hoist back in aircraft engines. When asked if she worked with men on the base, she answered, "I sure did, a lot of them, and they resented us…But after we got on base and they got to know us and they saw that we could do the same job that they could do, then it was all right." Rosemarie recognized the magnitude of the work she did. She truly did have lives depending on her. "I was scared to death

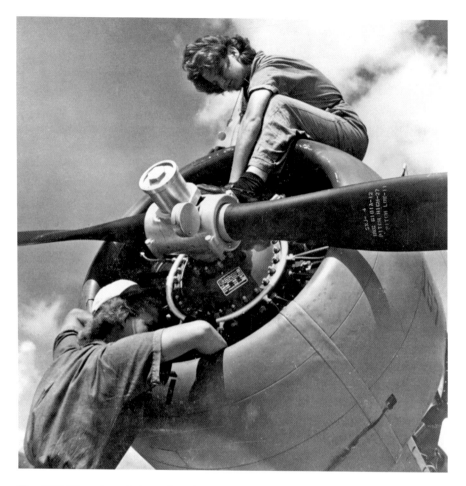

Two WAVES work on the propeller of a plane. *Naval Historical Foundation.*

every minute that I sat in that crew's room and one of my planes were [*sic*] in the air, and I knew that I had that pilot's life in my hands." After the war, Rosemarie took advantage of the GI Bill and went to Youngstown College in Ohio. She went on to become a teacher.

Elizabeth Hickcox, who was born in Woodstown and grew up in Glassboro, New Jersey, joined the WAVES in March 1944. After basic, she trained as a cook. Her training involved getting up in the middle of the night to prepare and cook breakfast for the recruits. In the middle of the summer, she worked in the kitchen for hours and then went back to a bunk without air conditioning. With a lot to learn about cooking en masse, Elizabeth had her work cut out for her. From cracking eggs for breakfast to peeling potatoes,

she learned every step involved in keeping a mess hall full of recruits and officers well fed. Working diligently alongside the men in the kitchen, she said, "Well, I can't say we were treated bad, but we were not encouraged and we were not helped along the way." Women filling in for men in any job could be met with either hostility or acceptance.

During World War II, more than eight thousand navy women became officers. After the conflict, the WAVES were slowly demobilized like the other military branches. After Director McAfee left her position in 1945, Jean Tilford Palmer assumed the leadership of the WAVES. Palmer launched a campaign to gain permanent status for women in the regular navy. With Palmer's exit from the navy in 1946, the task of gaining the proper legislation fell on the shoulders of Joy Bright Hancock. On June 12, 1948, the Women's Armed Services Integration Act was approved.

By the end of the war, about eighty-six thousand women served in the WAVES. Despite the reluctance of the navy, these women accomplished the original task of freeing up more men for combat. However, their contributions amounted to so much more. Aside from proving that women could do many of the jobs that were viewed as too complicated for them, they showed the world that they could endure navy discipline and helped to pave the way for future women to be integrated into the service. According to McAfee, "The girl in a job equally open to men, had to be better than the ordinary man to prove her capacity. When she had done so, she was often commended as though she had performed a miracle." Perhaps the most enduring legacy of these World War II WAVES is their impact on the present. Currently, women represent an impressive 18 percent of the navy and have a permanent place in times of peace.

"RELEASE A MAN FOR SEA"

The SPARs

Moreover, since we were untried, we knew that if one failed, we all failed. That is why we tried so hard.
—Dorothy C. Stratton

On January 28, 1915, President Woodrow Wilson signed a congressional bill that created the Coast Guard. The newly established Coast Guard was under the supervision of the U.S. Department of the Treasury in peacetime and

under the control of the navy in times of war. With the WAC and WAVES programs officially underway, the U.S. Coast Guard also allowed women into its ranks during World War II. Faced with a manpower shortage much like the other branches of the military, the Coast Guard created a women's reserve called the SPAR. President Franklin Delano Roosevelt officially established the women's reserve of the Coast Guard when he signed Public Law 773 on November 23, 1942, to "expedite the war effort by providing for releasing officers and men for duty at sea and their replacement by women in the shore establishment of the Coast Guard and for other purposes." The SPARs were a small group, amounting to only about ten thousand volunteers during World War II. The acronym SPAR was a combination of the Latin "Semper Paratus" and its English translation "Always Ready." Dorothy C. Stratton, who came up with this slogan, was a lieutenant in the WAVES before serving as the first director of the SPAR under the title of lieutenant commander.

Recruitment began in December 1942. Because the Coast Guard was a smaller branch of the armed services, finding recruits was far more difficult for the SPARs than for the women's groups of the army or the navy. As with any war effort, successful advertisement was essential. Information about SPAR recruitment was added to WAVES information and distributed separately, as well. Recruiters were encouraged to go out and actively pursue candidates for the job. There were several obstacles standing in the way of recruitment efforts for the SPARs, which included the high wages paid by wartime production companies, objections by family members and the desire to stay close to home. A musical called *Tars and SPARS* made rounds across the country in the summer of 1944. Although it is hard to say how much this entertainment actually influenced women to join, it provided some publicity. Much like the other female service branches, the women of the Coast Guard went through basic training and were then sent to serve in offices or bases to free up the men for active duty. Since many members of the SPAR served in Coast Guard stations around the coastal United States, there were many stationed in New Jersey.

Regular recruits needed two years of high school, and officers needed two years of college plus two years of professional experience. Recruits were to be American citizens between the ages of twenty and thirty-six with no minor children. Officers could sign up until their fiftieth birthday. Acceptance was contingent upon successful completion of an aptitude test, a physical examination, the submission of three character references and an interview. Married women were accepted as long as their husbands were not in the Coast

Guard. Any SPAR who became pregnant was obligated to resign from duty. The first SPAR recruits were already members of the navy WAVES.

Training or indoctrination efforts were modeled after the WAVES program. Like other branches, basic training for SPARs was strict and regimented. In the early stages, basic training lasted about five weeks for regular recruits but was extended to six in October 1943. SPARs received instruction in military history, insignia, customs, navy organization and regulations and ships and aircraft. These women faced middle-of-the-night fire drills, white-glove inspections, deck-swabbing lessons, homework and a final exam before officially being released to a duty location. One SPAR begrudgingly wrote, "We hit the deck around here at 0615 which is the Coast Guard way of saying 6:15 a.m., which is too darned early no matter how you say it."

Initially relegated to office work, SPAR members eventually branched out into specialized positions within the Coast Guard. By the end of the war, the women of the Coast Guard held about forty-three different ratings. These specializations included but were not limited to radioman, carpenter's mate, radio technician, fireman, air control tower operator, parachute rigger, photographer's mate and yeoman. SPARs also manned the new and very secret LORAN, or long-range aid to navigation, monitoring stations. SPARs manned these stations twenty-four hours a day. Basically, radio signals were sent out to ships from land stations along the coast in order to determine their position. The signals were recorded by SPARs every two minutes. After September 27, 1944, members of the SPAR and the WAVES could be stationed outside the continental United States. The first SPARs arrived in Alaska and Hawaii in 1945.

As with other women's branches, the SPARs were limited in what they could do. Director Stratton wrote, "We couldn't go to sea, let alone command a Coast Guard Cutter. We had no authority over any man in the Coast Guard, officer or enlisted. We couldn't serve beyond the continental limits of the United States. Our command authority was severely limited." Like the rest of the country in the 1940s, the military was segregated. In fact, it was not until October 1944 that the SPARs began recruiting African American women into their ranks. Until the Coast Guard finally accepted African American women into the SPAR, a standard letter was issued in response to any enlistment inquiries. It read, "At the present time, the U.S. Coast Guard is not enlisting Negro women. However, this office will be glad to keep your application on file for future reference. Your patriotic interest in the SPARs and your desire to be of assistance are appreciated." This disappointing response was sent again and again until the end of the conflict.

The women who were accepted quickly learned that there were indeed many rules to follow. One SPAR recalled, "Whether we were age 20 or 45, we learned to do exactly as we were told, and we held our tongues, even if they were sometimes tucked in our cheeks. We took it either gracefully or grudgingly according to our nature, but we took it." Uniforms for SPAR enlistees were the same as the WAVES but with different insignia. Some recruits were less than fond of their new uniforms. One wrote, "I wouldn't let anyone read this for the world but today we got our uniforms and I look like something that even the tide wouldn't go out with. I think we're supposed to look trim and snappy and feel a glow of pride—it said so in the recruiting literature anyhow—and I'm trying like mad to glow but my uniform is so big." As it turned out, trying "to glow" was only one of an assortment of crucibles ahead for recruits. The interaction with military men could be positive or negative depending on the circumstance. While some welcomed the women with respect and gratitude, others made life difficult for them. One SPAR commented, "The attitude toward us ranged from enthusiastic reception through amused condescension to open hostility." As with other branches, rumors concerning the morality of Coast Guard women took on a life of their own.

Many enlisted women, including members of the SPAR, went above and beyond their official duties during World War II. They donated blood to the Red Cross, served as nurse's aides, visited injured soldiers recovering in hospitals and helped with clothing and scrap drives. The patriotism of some of these women, along with the spirit of volunteerism, was truly amazing. So, why did thousands of women join the SPAR during wartime? The most common answers were that they felt a responsibility because a male family member was serving and that they had a sense that it was their patriotic duty. According to Coast Guard data, about one-third of recruits reported that their parents objected to their enlistment. Some women joined because they felt that, as a small branch of the armed forces, the Coast Guard offered more advancement opportunities. Some cited the efforts of the recruiter in finalizing their decision to join. Still others simply choose the Coast Guard because they knew people who were already involved. Of course, the prospect of traveling, personal improvement and promise of adventure were also factors for some. Like other women's branches of the military, the SPARs were disbanded several months after the end of World War II in the Pacific. Demobilization for the SPAR was officially completed on June 30, 1946.

FEMALE MARINES

Despite some vocal opposition to the idea, the Marine Corps Women's Reserve was officially created in February 1943. The women who joined the marines did not receive a snappy acronym like the other female branches of the military. They were simply called marines. In fact, General Thomas Holcomb stated with authority, "They are Marines. They don't have a nickname and they don't need one. They get their basic training in a Marine atmosphere at a Marine post. They inherit the traditions of the Marines. They are Marines." With slogans like "Free a Marine to Fight" the drive to find qualified women for training was on. Those select few women who were accepted trained at Hunter College until June 1943, when training was moved to Camp Lejeune, a marine training base in North Carolina. Women of the marines wore the same forest green uniforms as marine men, with some tailoring differences, of course. Women were prepared for any of hundreds of different jobs. They were even trained in select combat skills, although they were not allowed in any actual fighting situations. By the end of World War II, around twenty-three thousand women from all over the United States had joined the marines.

The first director of the Women's Reserve of the Marine Corps was Ruth Cheney Streeter, a resident of Morristown, New Jersey. Many members of Streeter's family were involved in the war effort in some way. In fact, all three of her sons served in the military during World War II. Streeter applied for several military branches before joining the marines. Since she already had a commercial pilot's license, she put in several applications for the WASPs but was turned down because, at the age of forty-seven, she was twelve years beyond the limit for acceptance. Determined to do her part in the war effort, she applied to be a flight instructor for the navy WAVES. After being informed that she would not be allowed to instruct anyone in the air, she withdrew her application. She was selected as the director of the Women's Reserve of the Marine Corps after a nationwide search for the right woman for the job. During the search for a director, General Holcomb said, "I've got to have somebody in charge whom I've got complete confidence in." Her patriotism, professionalism and determination to join the war effort were convincing enough to gain her the opportunity. She did not disappoint General Holcomb.

As with the other women's military branches, New Jersey women answered the call for the marines with enthusiasm. Streeter herself went on a speaking campaign to spur interest in the marines. The tour was essential

in swaying the opinions of parents who, according to Streeter, were reluctant to "let their little darlings go in among all these wolves unless they thought that somebody was keeping a motherly eye on them." Marian Estelle Gold Krugman, born in Weehawken, New Jersey in December 1923, served in the Marine Corps Women's Reserve during World War II. Why did Marian choose the marines? "Because it was the best," she laughed. "You should know that. I mean, for one, it was the hardest to get into." Of course, she had many other reasons to get involved in the war effort. She said, "And you know, I guess part of it is genetics. I take after my father. Part of it is, like my father, I want to be where the action is." Marian's family was Jewish, and her father still had family living in Poland during World War II. Concern for the increasingly perilous situation of the Jewish population in Europe was another motivation for her to do her part to fight the Axis powers. Once accepted, Marian went to basic training at Camp Lejeune, North Carolina, for six weeks. During that time, her only connection with friends and family members was through writing letters.

Marian went to great lengths to prove that she could do the same tasks as the men on base. Even decades later, one particular instance stood out for her. She said, "In fact one of the things I did on my own was jumped from a top, a very high board like the men, and the women didn't have to do that, but I wanted to show them that I could do it, wanted to show the guys that I could do it." After basic training, she was stationed in Santa Barbara, California. When thinking back on her time as a marine, she said, "I learned to do things in the military and did things on my own and handle situations on my own that really prepared me for my future life."

Edna Smith Wilson of Plainfield, New Jersey, served in the marines from 1943 to 1946. The oldest of five children, Edna joined the Marine Corps to follow in her father's footsteps. Edna recalled basic training as a positive time despite some difficulties. There was a great deal of marching, classes and, of course, waking up at the crack of dawn. After completing basic training in North Carolina, she was assigned to a base in San Francisco, California. As was common during that time, she traveled from North Carolina to California on a troop train that transported both men and women. She said:

> We went by train, southern route, and most of the time there was no way to feed us. We also were attached to a troop train. And the troops, naturally, were fed first. So we never knew when we would have breakfast, lunch, or dinner. But the thing they often—most often did, was they must have known ahead, called ahead to the towns, the little cafes. And then they would

march us off the train into the town and into the cafes. And if you don't think that was the most fun for us, as well as for the people in town. A lot of people don't know that that's how we managed to eat between Camp Lejeune and San Francisco.

All told, the women of the marines had an impressive record during World War II. Although they were a select and small group compared to the army and navy women, they successfully accomplished the task of freeing marines for active service. As another side effect, they proved that women could endure training and be proficient in countless occupations formerly closed to them. Marine women were welders, parachute riggers, mechanics, drivers, mapmakers and much more. They completed training in about thirty different specialist schools.

4
FLYING FEMMES

THE FEMALE PILOTS OF WORLD WAR II

You and all WASP have been pioneers in a new field of wartime service, and I sincerely appreciate the splendid job you have done for the Army Air Force. You, and more than nine hundred of your sisters, have shown that you can fly wingtip to wingtip with your brothers. If ever there were a doubt in anyone's mind that women can become skillful pilots, the WASP have dispelled that doubt.
—*General Henry H. Arnold*

With the many changes that occurred during World War II, the flight training of women was certainly among the most dramatic. Never before had women stepped into such roles. This was so much more than stepping into a desk position to free a man to fight. Gender-based stereotypes of women as too emotional for flight were hard to surpass. Yet somehow, the female pilots who served during World War II did just that. Early on in the conflict, Jacqueline Cochran, already a respected pilot, believed that female pilots would be an essential part of the war effort. She wasted no time in contacting the commander of the Air Force. At about the same time, Nancy Harkness Love, another female pilot, was in contact with the Ferrying Division of the Army Air Force. Her idea was that women could free men for active duty by taking over ferrying responsibilities. With these two persistent women fighting for the inclusion of female pilots and the war heating up in Europe, the lack of male pilots available soon warranted the recruitment of women.

In her September 1942 "My Day" column, Eleanor Roosevelt endorsed the idea of female pilots:

The CAA (Civil Aeronautics Authority) says that women are psychologically not fitted to be pilots, but I see pictures every now and then of women who are teaching men to fly. We know that in England, where the need is great, women are ferrying planes and freeing innumerable men for combat service…I believe in this case, if the war goes on long enough, and women are patient, opportunity will come knocking at their doors. However, there is just a chance that this is not a time when women should be patient. We are in a war and we need to fight it with all our ability and every weapon possible. Women pilots, in this particular case, are a weapon waiting to be used.

Finally, in early September 1942, the WAFS (Women's Auxiliary Ferry Squadron) was formed. Headed by Nancy Harkness Love, the group started out with a mere twenty-eight members. Days later, the WFTD (Women's Flying Training Detachment) was formed with Jackie Cochran as leader. When the WAFS and the WFTD combined in August 1943, the WASPs (Women's Air Force Service Pilots) were born. Unlike the other branches of the military, the women of the WASP were never given military status during World War II. They were considered civilians who worked with the air force. Regardless, these women aided the war effort bravely, defying social stereotypes.

Jackie Cochran finally had approval for her group of female pilots, but a larger task now loomed ahead. In a letter to the *Fifinella Gazette* (fifinellas, female gremlins used as WASP mascots, were designed by the Walt Disney Company and given to the group to use free of charge), she addressed the first classes of women being trained:

With the start of the war, I became convinced that there was a sound, beneficial place for women in the air—not to compete with or displace the men pilots, but to supplement them—and I never let up trying to establish in practice the birth of my belief…What will be the ultimate result—good or bad—will be up to the girls themselves. You of the first classes will have the real responsibility. By your actions and results the future course will be set. You have my reputation in your hands. Also, you have my faith. I have no fear—I know you can do the job.

The women of the WASP felt the pressure of this responsibility, but many still kept their sense of humor. The *Fifinella Gazette*, a newsletter produced by members of the WASP, contained factual reports speckled with poems,

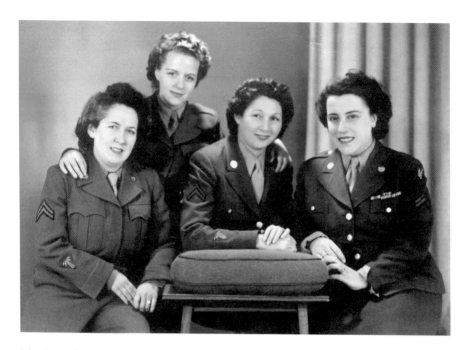

Members of the WAACs Air Corps train in Newark, New Jersey. *National Guard Militia Museum of New Jersey.*

comics and generally good-natured sarcasm about the life of a WASP trainee from the women who knew it best. The opening of an April 1943 issue stated, "It is claimed that demerits are issued for everything but breathing. Breathing comes under the heading of Meteorological Phenomena, however, it cannot possibly compete with the breeze that blows at Avenger." The author was referring to Avenger Field in Sweetwater, Texas. In another article, a trainee complained, "Hairnets cannot cover the ravages of Texas dust on once lustrous locks. It takes but three weeks of flying fumes to rob faces of any possibility of being skin-you-love-to-touch. Fingernails crack, and the polish chips, and morale gets lower than a Houston fog." In another column, a trainee commented on their lack of time off. She joked, "Remember way back when we thought we'd get a week off for Christmas??????"

Bernice "Bee" Falk Haydu, a New Jersey native who was born on December 15, 1920, in Monmouth County, was a member of the WASP. In her book, *Letters Home, 1944–1945*, Bee recalled that her family never expressed any strict idea that women should stay at home. While looking for college courses that might interest her, she noticed that the Newark College of Engineering was offering aviation classes. Reasoning that flight was an area that would

continue to offer job opportunities, she enrolled in the program in 1943. Bee truly loved her training and completed her first solo flight on August 1, 1943. A short time later, she applied and was accepted to the WASP. After initial acceptance, candidates supplied character references, obtained release forms from current employers if their jobs were related to the defense industry and passed the Army Air Force Physical for pilots. Next on the agenda was a trip to Avenger Field for seven months of training in the dry Texas heat. The recruits themselves paid for transportation to the facility. Failure in any part of the training program meant a trip home, something the recruits called "washing out."

Before she left for Texas, Bee recalled the tense and uncertain atmosphere of New Jersey during the war. "Those days, everybody was patriotic, even citizens who weren't serving in some military manner. It was just, we were so afraid that we were gonna lose that war." People undoubtedly banded together to support the military effort. She said, "There was a huge spirit of cooperation." In this spirit of camaraderie, both her love of flying and her desire to do something for the war effort led her to apply to the WASP. "We saw an ad in the paper that they were recruiting for the Women Air Force Service Pilots and they were going to be doing interviews in Newark. So six of us went down with our log books and our paperwork and everything and we were all accepted in the WASP training program." Embarking on her long journey from a train station in Newark, Bee and five other women traveled to Texas via coach class.

Bee fondly recalled Jacqueline Cochran's campaign to convince the army air corps that they should train women:

> She wanted the women to be able to do everything stateside that the men did and then they could go off to war because the jobs were being done here by women…We did all the jobs, not just ferrying aircrafts, like towing targets for the anti-aircraft practice shooting or flying at night so that beacons would have an opportunity to practice or flying gunners so they would have practice shooting from a moving aircraft.

Going from civilian life to basic training was an adjustment. Bee went through a program similar to that of the male cadets except that aerobatics were not as prevalent because WASPs were not permitted to fly combat missions. Although stress abounded, Bee persevered. She recalled, "Well, it was because we were flying 65 horsepower aircraft and in those days before you even soloed an airplane you had to know how

to put it into a spin and then take it out of a spin." She remembered one particular trial during training:

> When we went down to Sweetwater Avenger Field, Sweetwater, Texas where we were trained, we started out in a Stearman, which is an open biplane, which was 220 horsepower, so that was quite a jump. And in the beginning of '44 they wanted to experiment to see if, because it's usually primary, basic, advanced, and they wanted to see if they could eliminate the basic training and have you go directly from primary into advanced. They said well let's try it out on the women and if women can do it then we'll change the training. So we went from 220 horsepower aircraft directly into a 650 horsepower aircraft. It was quite a jump, but we did it.

Through many shocking adjustments, such as early wake up calls and regimented routines, Bee kept a positive attitude. There was a demerit system for every possible infraction, no matter how minor. Seventy demerits could earn a recruit a trip home. Physical training was a difficult adjustment for many, especially in the cruel Texas heat. Any free time was spent cleaning the bay or studying. The recruits were constantly busy. In a letter written to her mother, Bee said, "Next a.m. we got a bit of good news. We are supposed to have PT right after breakfast but it was called off today. This gives us a whole hour to ourselves."

When asked about the most nerve-racking part of training, Bee answered, "You were always afraid of the testing. You had two deck rides in every phase and there were three different phases. If you didn't pass then you could be washed out, so we were always very apprehensive about any flight testing." The instrument training presented a particular hardship for Bee. In a letter to her mother on June 6, 1944, she said, "I am practically on the verge of a nervous breakdown. Instruments have turned from a course of interest to one of torture." Many of her letters home expressed a fear that she would wash out and be sent home. Of course, this worry never materialized, and Bee completed her training. Her first assignment was at the Pecos Air Force Base in Pecos, Texas.

The acceptance of women in the air force was not always easy. Some people offered reluctant acceptance and others were absolutely antagonistic toward women pilots. Bee recalled:

> There was resentment against women by some but certainly not by all. There were some that were at a base where the women were sent and they refused

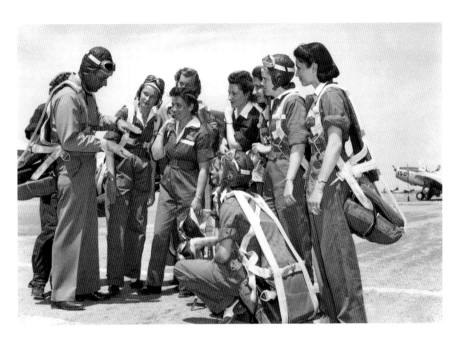

WASP trainees and their instructor. *U.S. Air Force.*

to let them fly anything except the smallest aircraft. But when things like that happened, they would complain to Jacqueline Cochran, who was in Washington, D.C., and when she went out to meet anybody it was like General Arnold was there. She would be speaking for him and she would go out and she would straighten out the commanding officer and tell him that they were to be able to fly anything and everything.

Luckily, Bee did not personally experience any such resentment. She was lucky enough to encounter military men who treated her with respect. When asked how her life changed after being in the WASP, she fondly recalled, "Well, it completely turned it around. I had never dreamt about a career in flying." She continued her flying career after the war. She started a ferrying business, sold airplanes and joined a group of veterans who established a flight school.

The WASP program was considered a success. General Henry H. Arnold, the commanding general of the army air force, praised the women of the WASP. He proudly stated, "Certainly we haven't been able to build an airplane you can't handle…We will know that they can handle our fastest fighters, our heaviest bombers; we will know that they are capable of ferrying, target towing, flying training, test flying and the countless other activities

which you have proved you can do." Despite an impressive service record, the WASPs were never integrated into the U.S. Army Air Force. The group was disbanded on December 20, 1944. Thirty-eight WASPs died during World War II. WASPs were not given military status until 1977.

British Air Transport Auxiliary

The often overlooked female volunteers of the British Air Transport Auxiliary (ATA) flew planes back and forth during World War II. As the initiative of Gerard d'Erlanger, director of British Airways, the ATA was envisioned as a way for pilots who would not be readily accepted into the military to help the war effort. By September 11, 1939, mere days into World War II, the first twenty-six pilots of the ATA stood at the ready. It was not long before the need for more pilots surfaced. With Britain in a tense standoff with Nazi Germany, more pilots where necessary to fly combat missions, which in turn meant that more pilots were required to ferry planes. Desperation for more recruits led to campaigns for pilots around the world, and many American citizens became members of the ATA.

Both men and women served in this capacity and ferried planes to be repaired or delivered from manufacturing points to squadrons. Within the first month of the war, women were considered as possible pilots. By New Year's Day 1940, the first handful of women had signed on with the ATA. Much like other duties performed by women during wartime, these pilots helped to free up more men for active combat. These civilian pilots had dangerous jobs. There were instances when they were shot at during ferrying missions. Bad weather was a constant concern. Pilots often flew several different, sometimes completely unfamiliar, planes in any given day. The threat of enemy attack or contact was made that much more disastrous when coupled with the fact that these pilots were unarmed during their flights. Although the casualty rate for the ATA was low, many brave men and women still lost their lives flying for this auxiliary.

The pilots who served in the ATA came from twenty-five different countries. One pilot in particular, Suzanne Humphreys-Ford-de Florez, was a New Jersey native. Born in 1915 in Far Hills, New Jersey, Suzanne was intrigued by aviation at an early age. Suzanne began taking flight lessons when she was sixteen. By the time she entered college at New York University, she was quite the talented pilot. Suzanne performed in air

shows, often making the local papers. Once the war was on, Suzanne, like many others, had a deep desire to do her part. As luck would have it, she got her chance with the ATA. During her time as a ferry pilot, she flew around seventy-five different planes. She was stationed in Scotland and Northern Ireland. Her duties with the ATA came to an end on October 31, 1945, and she soon returned to the states.

All told, 157 men and 16 women died flying for the ATA during the course of the conflict. The ATA was deactivated in November 1945. Its pilots' records were truly amazing, with around 309,000 aircraft deliveries completed. These brave men and women proved that civilian pilots were an invaluable addition to combat forces. The women, in particular, proved that they could learn to fly virtually any type of plane, even under the most stressful conditions.

AFRICAN AMERICAN WOMEN JOIN THE WAR EFFORT

So you felt as though you were fighting two wars. Of course, you fought the men and the women war, the war between the men and the women in some cases. I didn't have that situation, but in some instances they were. Then you had the racial thing that you were facing. Then you had the war that you were fighting between overseas and the United States. So you were fighting three wars at the same time, and that was very difficult.
—*Marjorie R. Suggs Edwards*

The America of the 1940s would seem unrecognizable to those who did not experience it. Until the Civil Rights Act of 1964, segregation was still both legal and socially acceptable in the United States. The armed forces and many volunteer organizations were segregated, as well. Want ads in local newspapers still had separate classified categories for African Americans and women. "Whites only" was not an uncommon job requirement. Despite this atmosphere of discrimination, many black men fought for America, and black women joined in the war effort through new military branches and volunteer opportunities. They fought for a country that still considered them second-class citizens. Before the civil rights movement, in an age when the "separate but equal" doctrine created social barriers that would not crumble for several decades, these women still chose to serve their country. With great effort, they entered into civil defense jobs, women's military branches and volunteer organizations.

Black women in New Jersey, as in other areas, faced both racial and gender-based discrimination. Since the civil defense industry

needed every woman possible, U.S. citizens, especially industry owners and workers, needed to be prepared to accept them onto job sites. Even President Roosevelt acknowledged the necessity of accepting all women as workers. Executive Order 8802, issued in June 1941, stated:

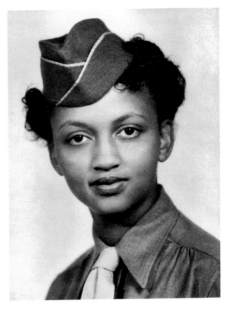

Portrait of Betty Dillihay of the WAACS. *Atlantic City Free Public Library.*

It is the policy of the United States to encourage full participation in the national defense program by all citizens of the United States, regardless of race, creed, color, or national origin...it is the duty of employers and of labor organizations, in furtherance of said policy and of this Order, to provide for the full and equitable participation of all workers in defense industries, without discrimination because of race, creed, color, or national origin.

Sadly, this idea was not accepted by all industries. Even if it was accepted by business owners, sometimes employees walked off jobs at the mere appearance of black women. Before the war, many worked in low-paid service positions. Nationwide, the percentage of black women who joined in industrial work rose from 6.5 percent to 18.0 percent during the war. They were crucial to successful wartime production across the United States. However, entry into the civil defense industry was no easy task. As the need for industrial workers grew, single white women were the first targets of staffing efforts. As the war progressed and more products were required, married white women were the next focus. Extreme labor shortages forced some industries to hire black men and eventually black women. Once these women were hired, their struggles were far from over. They endured harassment and segregated facilities and often had to perform the most dangerous or dirtiest jobs. In fact, some industrial leaders still refused to hire black men or women altogether.

It is estimated that around 6,500 black women served in the WAC during World War II. Although black women were eligible to join the WAC, they

still faced segregation, as did military men. Mary Heckendorn recalled seeing the segregation firsthand: "And you know I felt terrible later when I realized I didn't even notice the fact that there were no black women at this. We just grew up in an atmosphere where that was just the way it was. And later when I began to realize what was going on in the world I felt so guilty." The WAC separated black and white enlistees in both training and duty stations. In 1943, Marjorie Randolph Suggs Edwards joined the Women's Army Auxiliary Corps, soon to be the Women's Army Corps. Marjorie grew up in Passaic, New Jersey, which was a very small community at that point. Not far from New York City, the area became a melting pot for many different immigrant communities, including Germans, Italians and others. With a grandmother from Havana, Cuba, and a grandfather from Jamaica, Marjorie's own family had very different backgrounds, as well. Growing up in such a diverse community, she had a unique experience with many different cultural backgrounds. A sense of patriotism and a desire to do something to help the war effort inspired her to join the WAAC.

It seems she was not the only one in her family to feel this way. Her father was a veteran of World War I, and two of her brothers served in the navy during World War II. Despite this, her mother was less than fond of her idea to join the military. It seems the campaign to "free a man" to fight held a negative connotation for many. Some believed that somehow women who volunteered were responsible for sending more men to active combat. Marjorie, however, did not believe such ideas. "I thought about it, but I said they were going to go anyway, whether I went or not. If I could be of any service at all, maybe I could keep them from going and they wouldn't have to go. I mean, there are two sides to every story. So yes, I cried with every truckload that went out because I was a truck driver." While in the army, Marjorie held many positions, including physical training instructor and motor pool driver.

Early in the war, the women's army was the first branch to accept black women. For Marjorie, who grew up in a fairly integrated community, the shock of segregation was something unexpected. She recalled, "I knew about segregation, but it went right over the top of my head because I didn't grow up with it." In serving her country, Marjorie still had to deal with separate facilities and restrictions on where she could go. She remembered one instance in particular:

I'd go to the fountain and say, "Why aren't we supposed to drink out of that fountain?" I looked around to see if there was anybody drinking out of the fountain, and no people of color were drinking out of it. So I drank out

of it to see what the water was like. And the people of color, they were so amazed. "You're not supposed to do that. You're not supposed to do that." Nothing happened, fortunately, but I really wondered why that was. That was one I couldn't figure out.

For Marjorie and many others, restrictions like separate drinking fountains made absolutely no sense. Despite the outstanding contributions of black men and women during World War II, these policies would take several more decades to change for good.

The 6888th Central Post Battalion, an all-black WAC contingent, arrived in Birmingham, England, in February 1945. Led by Major Charity Adams, this massive group of eight hundred women was charged with directing the mail flow for all U.S. service members, civilians and Red Cross volunteers serving in the European theater. It is estimated that this network included over seven million personnel. These WACs worked long shifts, sometimes on a seven-day-per-week schedule, to clear out mail. The work that this WAC detachment performed was instrumental in keeping up the morale of the troops and their families on the homefront.

Several other branches of the military reluctantly accepted black women into their ranks as the war moved along. In 1941, black women were allowed to join the army nurse corps in limited numbers. Started in 1943, the cadet nurse corps allowed black women entrance into their training from the start. Other branches waited until very late in the war to admit black women. The navy WAVES, for example, did not open recruitment for black women until October 1944. The first black navy officers were not commissioned until December 26, 1944. Because so few joined the WAVES, the navy decided not to segregate women during their service. Frances Eliza Wills and Harriet Ida Pickens were the first African American women to join the WAVES. It was not until March 1945 that the Coast Guard finally allowed black women to join. The WASP never accepted any black women as pilots. Many received rejection letters that stated, "Your desire to help your country in this time of war is praiseworthy. Unfortunately, there is no provision for the training of colored girls in the Women's Flying Training Program." The letter went on to suggest that the applicant try the WAC instead. For many women, letters such as this served as a stark reminder that they were not being judged on their abilities or potential but were merely rejected because of social prejudice.

Black women faced segregation in volunteer organizations like the USO, as well. Some volunteer groups refused to allow black women within their

ranks at all. Marjorie described the facility used for the black soldiers as a "barn." She said, "There was nothing to it at all, just folding chairs and things like that. We had the juke boxes that they could dance to and things of that sort, and that's about all there was."

As an air raid warden and USO volunteer, Alice Jennings Archibald was busy during World War II to say the least. Alice holds the distinction of being the first black woman to graduate from the Rutgers School of Education. Born and raised in New Brunswick, New Jersey, she had family ties to the Garden State that could be traced back for generations. Alice also worked in the civil defense industry as a completion clerk at the Raritan Arsenal. When asked why she decided to work at Raritan, she said, "Well, I guess they were advertising everywhere and, you know, and everyone wanted to do his or her bit at the time. If you weren't going into the service, you wanted to do something, so I got a job at the Arsenal." She continued, describing her job, "And I was a completion clerk. It wasn't hard, but the thing I thought of then, and I think of it now, what a waste it was. If someone at a camp wanted a screw, you had to write a whole requisition for, type up a whole paper with one little screw item on it, and mail it out." Alice was not the only family member involved in the war effort. Her aunt was a Red Cross volunteer during World War I. During the Second World War, she had three brothers who served in the military.

She did recall dealing with discrimination in the 1940s. The experience of going to see a movie stood out for her. She recalled, "Well, the movie theaters were kind of prejudice in that they wanted to send you…of color, up to what they called the 'peanut gallery.' Well, some of the theaters were like that." Sadly, that was not the only instance in which Alice observed discrimination firsthand. She said, "But where your prejudice came in was when you tried to get a position in the school system. Then you found out you couldn't get in because of your color…So when I graduated, there were no colored positions available, so I went south." Even traveling to North Carolina, where the job prospects were better in education, she dealt with prejudice. Not long after she arrived, a rather surly porter at a train station made it known that she could not use the "whites only" ladies' room.

During this time, many other black women joined the civil defense industry in New Jersey, performing tasks across a broad spectrum. In reality, the iconic Rosie the Riveter was made up of real women who looked quite different from the woman in the popular posters. Women of all ages and nationalities made wartime production in New Jersey possible. Their participation was so pervasive that it is difficult to quantify, even today. For instance, at the

Picatinny Arsenal, black women did many jobs like using a chamber gauge to check the alignment of cartridges, inspecting the rotor assembly after crimping and packing ammunition. They worked for the Curtis-Wright Corporation in Caldwell, New Jersey, which manufactured parts for military aircraft. Black women worked at the Eastern Aircraft Division of General Motors plants in Linden, Bloomfield and Trenton, New Jersey. They were welders and riveters, doing jobs that were both physically demanding and mentally taxing. Despite the move from low-paying domestic labor or farm work to factories, black women were still given the most dangerous or labor-intensive jobs. They could often be found working with unstable explosives or cleaning the plants.

Throughout the war, black women contributed to the war effort on both a national and state level. In New Jersey, they participated vigorously. In the civil defense industry, they worked at plants and arsenals ensuring production goals were met. They joined the WAC, WAVES and SPARs, freeing men for combat. While the navy nurse corps refused to accept them until 1945, they saved lives and helped the injured while serving at home and abroad in the army nurse corps. They sacrificed their time and ration stamps volunteering for the USO, the Red Cross and the AWVS. They participated in bond drives and scrap collections. They watched as their husbands, sons and brothers left to fight for the Allied war effort.

6

"DOUGHNUT DOLLIES"

AMERICAN RED CROSS VOLUNTEERS

If I could reach all of America—there is one thing, I would like to do—thank them for blood plasma and for whole blood. It has been a tremendous thing.
—*Dwight D. Eisenhower*

Each one of you who has a friend or relative in uniform will measure the significance of this crusade in your own heart. You—at your house today—know better than anyone else what it means to be sure that the Red Cross stands at the side of our soldiers or sailors or marines wherever they may be. All of us one hundred and thirty millions—know how indispensable to victory is the work of this great agency which goes on every minute of every day—everywhere on earth where it is needed.
—*Franklin D. Roosevelt*

The American homefront was a place of many opportunities for wartime involvement. With virtually every area of society mobilizing for war, American women faced unique challenges. With the pressures of caring for their own families in the midst of an economic depression and the looming involvement in war, many women who stayed at home still found the time to volunteer. Homefront volunteers often paid out of pocket for their activities. They used their own ration cards to purchase the ingredients to make cookies to take to the troops. Often, when they organized parties for the soldiers, they made their own decorations and snacks. In already difficult times, countless American women put aside their own needs so they could help the brave individuals fighting the war.

The American Red Cross was but one avenue women could take to help the war effort. As a volunteer organization that dates back to 1881, the year it was officially founded by Clara Barton, the Red Cross played an integral role in support activities during World War II. Originally, Barton was inspired to bring the organization to America when she saw the work of the Red Cross in Europe. After its founding, Barton went on to head the American organization for an impressive twenty-three years. As the years went on, the volunteer organization became a fixture during times of conflict. During the uncertain time of World War II, the Red Cross played a pivotal role in providing support activities on the homefront.

Volunteers organized blood drives, wrapped bandages and made care packages to send to troops overseas. Of course, not every volunteer stayed near her home. Some Red Cross and USO volunteers traveled wherever they were needed, including the front lines. Often called simply "Red Cross girls," these volunteers began going to Britain to help war-ravaged areas even before the United States officially became involved in the conflict. Thousands of Red Cross volunteers served overseas during the course of the war. Some women went right to the front lines to offer support. Nationally, over three and a half million women volunteered for Red Cross work during this time.

From tasks such as rolling bandages to working in field hospitals, the Red Cross was a valuable asset during the war years. As with other volunteer organizations, like the USO and the AWVS, the Red Cross made sure to keep up the morale of the troops whenever they could. In fact, like the USO hostesses, Red Cross volunteers also organized events like dances and game nights. Many activities of the Red Cross overlapped with those of the USO. It was not uncommon for a Red Cross volunteer to put together care packages to send to troops on the frontlines or to send food to prisoners of war overseas. They performed many tasks that may seem trivial at a cursory glance but were actually monumental to homesick soldiers. Volunteers of the Home Service section kept men and women of the military informed of personal news from the homefront, including weddings, births and other important milestones. Volunteers helped to make sure that messages were constantly flowing back and forth between the soldiers and their families. For these women, looking out for the emotional well-being of the soldiers was one of their most important contributions to the war effort.

As with other wartime activities, New Jersey was bustling with Red Cross groups. In response to the American entrance into the war, local Red Cross chapters appeared all across the state. A network like this was

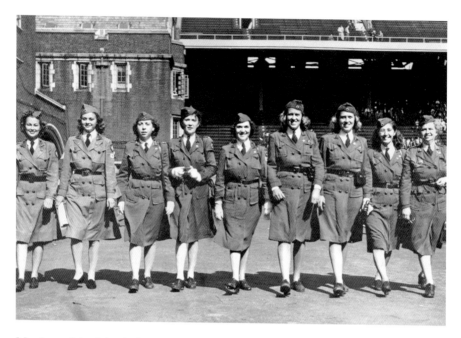

Members of the Atlantic County Chapter of the American Red Cross Motor Corps. *Atlantic City Free Public Library.*

essential considering the sheer amount of coordination and networking needed when organizing successful blood drives. As the war continued, blood for transfusions was needed more and more. Red Cross efforts to run successful blood drives saved countless troops who were injured in combat. President Roosevelt himself acknowledged the magnitude of the Red Cross's contribution to the war effort. In a speech he gave to officially open the Red Cross Fund drive in February 1943, he said:

> There is one way for you, however, to reach this hand of love and friendship across the ocean. For wherever our fighting men are—all over the world—the American Red Cross is by their side, extending always the arm of helpfulness and comfort…At home, we have grown accustomed to the role of the Red Cross in every national emergency, in every local catastrophe—a generous friend to those overtaken by tragedy. Even our enemies know about the American Red Cross, because it has never let international boundaries act as the limits of its mercy.

Roosevelt went on to declare March Red Cross month and to ask that at least $125 million be raised across the country to support the organization's efforts.

The Woodbridge Township Red Cross chapter sprang to work following the Japanese attack on Pearl Harbor. Realizing the need for money to mobilize their local chapter, volunteers in Woodbridge started fundraising immediately after America entered the war. A letter from the chairman of the national drive, Norman H. Davis, stated, "The American Red Cross again is called upon to serve our nation in war. Both nationally and locally we face vast and definite responsibilities for service to our armed forces and for relief to distressed civilians." Other initiatives soon followed. A knitting circle was formed to make items to send to the troops overseas. Volunteers collected items to furnish a sunroom at the Camp Kilmer Hospital. They tirelessly collected furniture, cups and saucers, sewing machines, chairs, radios, rugs and much more to make the area more inviting to the troops who stayed there to recuperate from wartime injuries. The impact these gestures had on the troops was made clear in a heartfelt thank you from Camp Kilmer:

> We, the men of Company D wish to extend to the people of Woodbridge our sincere thanks for the furniture and accessories sent to us for use in our Day Room. We wish to assure you that we feel that it is acts of kindness of this kind that make us feel that we of the Army are not the only Americans serving their country nor the only group of Americans making sacrifices. Again, we wish to thank you for the gifts and to pledge ourselves to do our part on the battlefront as you are doing on the homefront.

This spirit of total involvement was evident throughout New Jersey. Individual chapters completed activities that were similar to each other in some instances and more diverse in others. In October 1942, Woodbridge volunteers made care packages to send to the troops. Once the supplies for the kits were collected, local schoolchildren helped to pack them up. Each kit contained items like soap, playing cards, shoe polish, shoelaces, waterproof matches and sewing kits. Township women donated hundreds of their personal hours to the surgical dressing room. Whitney C. Leeson, chairman of the Woodbridge Red Cross Chapter, said, "Every woman can serve humanity in this war. The task falling upon us requires the concentrated efforts of not just a few, but rather the combined efforts of many women." Like the AWVS, the Red Cross also had a Motor Corps. The Woodbridge chapter had a dedicated group of women who served as drivers, taking soldiers back and forth to places like USO clubs and recreational sites.

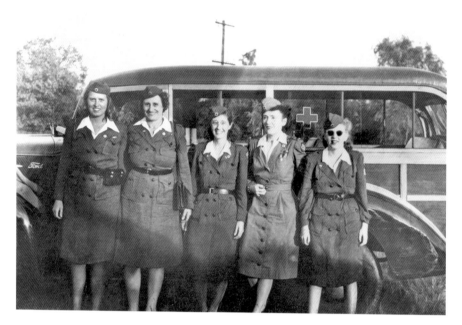

Members of the Red Cross Motor Corps at Lake Lenape. *Atlantic City Free Public Library.*

Local Red Cross volunteers in Riverton, New Jersey, an area in Burlington County that borders the Delaware River, formed a group with diversified activities during the war. They held knitting circles to make clothing to send to the troops on the frontlines. Members of the Red Cross salvage program collected paper and tin cans for the war effort. Every scrap helped. Even the school-age girls were involved. The voluntary services urged mothers to teach their children the value of patriotic service for the war effort. While the Red Cross only officially utilized adult volunteers, they were not opposed to helping the youth get involved in the war effort. In Riverton, local Girl Scouts helped with blood drives by soliciting blood donor pledges door to door.

Junior volunteers of the Red Cross were active in various chapters throughout the state. In South Amboy, high school students volunteered for a variety of activities to support the troops. Art students made handcrafted Christmas menus for the navy, sophomores and seniors made party favors for parties and dances and freshmen and juniors made party place cards. Other students took the initiative to create cards with crossword puzzles to send to the troops at Camp Kilmer. Volunteers considered talented seamstresses made utility bags and seat covers. Students also constructed their own jigsaw puzzles and clothes hangers for the navy.

Since Red Cross volunteers usually had food on hand, most commonly coffee and doughnuts, they acquired the nickname "Doughnut Dollies." One army officer admiringly listed the many different needs these volunteers filled, "Hot coffee, doughnuts, sandwiches, sewing on buttons, mending torn shirts, listening to homesick boys, helping to write their letters, giving assistance at all hours of the night at the base hospitals, never complaining and always smiling." The praise given to the women of the Red Cross by members of the armed services littered local papers and filled mailboxes. In a letter to the Red Bank Red Cross unit in 1945, a seaman first class of the U.S. Seabees expressed his heartfelt thanks for a Christmas care package he received while stationed at Marjuro Island in the Pacific. He wrote, "Thank you ever so much for the Christmas package that you sent to me. It made me feel pretty proud of my home town when it was the only Red Cross chapter to send a package to a person from that town. There are fellows in this unit from all over, and I was the only one to receive a package from their home town chapter." The Seabees got their nickname from the initials CB for Construction Battalion. They were responsible for building various construction projects for the war effort, including airstrips, hospitals, roads and bridges. They worked in the European and Pacific theaters, often under enemy fire.

Keeping in stride with the readiness campaigns of local defense councils, the Red Cross of Monmouth prepared for possible emergencies by having mock disasters. The proximity of the Monmouth shore to New York Harbor made the defense of the area vital. The possibility of an attack was something that residents hoped they would never have to deal with, yet they refused to be caught unprepared. In February 1944, volunteers attended a preparedness drill. The scenario was that a ship had "run aground" off the coast. Red Cross volunteer units scrambled to respond as if the event was an actual emergency. Women swiftly brought medical supplies, blood plasma, food and other necessities to the site. Emergency responders like local police, firefighters and ambulance workers sped to the scene with sirens blaring. The mock emergency was deemed a success.

Another well-known group of Red Cross volunteers were the nurses' aides. At Tilton General Hospital, located in Fort Dix, New Jersey, volunteers set up a continuing recreation program for injured military men. This program included arts and crafts, films and card games to pass the time. Volunteers from the Ladies Garment Workers Union of South Jersey even filled Christmas stockings for the soldiers recovering there. The donations and generosity of New Jersey's small business owners, religious groups and others

were often the only ways to keep the soldiers comfortable and occupied. The drain on resources due to the extreme cost of the war effort placed the responsibility for troop recreation firmly on the shoulders of New Jersey's citizens. Local organizations donated furniture to make the common areas of the Tilton General Hospital look more welcoming. Through these efforts, the soldiers had comfortable places to socialize or write letters.

In Atlantic City, the Thomas M. England General Hospital was the destination for many of New Jersey's volunteers. In anticipation of the possible casualties involved with the coming Allied invasion of Europe, a massive transformation occurred in the resort town. To meet this looming demand, the U.S. Army transformed five hotels into the largest military hospital in the country. The Dennis, Colton Manor, the Traymore, the Chalfonte and Haddon Hall were all integrated into one facility, which had the capacity to house over 4,700 patients. The main staging areas for patients were the Chalfonte, Haddon Hall and the Traymore while the Dennis housed personnel who worked at the hospital and the Colton Manor was used to house nurses. At the formal dedication of the hospital on April 28, 1944, Lieutenant General Brehon Somervell noted, "It's a matter of pride to the Army Medical Corps and it should be a matter of satisfaction to all Americans to know that we will have ready and waiting, adequate facilities for all our battle casualties." After this ceremony, the hospital became an essential part of wartime New Jersey.

With such a large mandate, the hospital also required the aid of numerous volunteers, many of whom were members of the American Red Cross. The women of England General Hospital were drawn mainly from Red Cross chapters in Atlantic County, Cape May County, Salem County, Vineland, Millville and Bridgeton. Volunteers wore many hats during World War II. Social services offered to soldiers included giving general advice, assistance in filing claims, filling out emergency furlough paperwork and more. Recognizing the need for mental as well as physical rehabilitation, volunteers paid special attention to setting up recreation activities. Movie nights were a popular pastime around "Camp Boardwalk." Concerts, stage shows and parties were organized and staffed by Red Cross volunteers.

The Red Cross Hospital and Recreation Corps was set up at Thomas England General in March 1943. In that same month, an estimated 180 Gray Ladies volunteered at the hospital. The nurses' aides, another vital unit of the Red Cross, joined the army of volunteers in Atlantic City in January 1944. As was the case in other areas, the motor corps was responsible for driving patients to different recreational activities and other places as

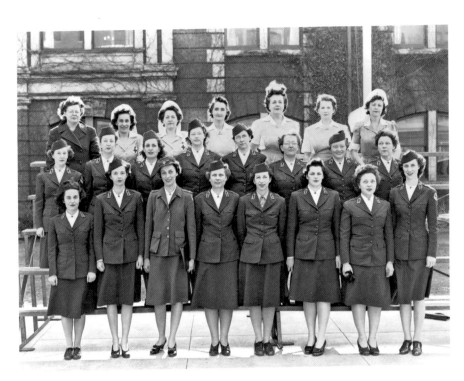

A group of women in Red Cross nurse and military uniforms. *Atlantic City Free Public Library.*

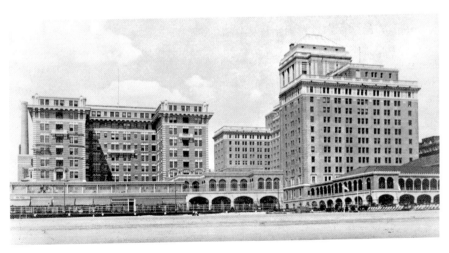

An exterior view of the Chalfonte-Haddon Hall as Thomas England General Hospital. *Atlantic City Free Public Library.*

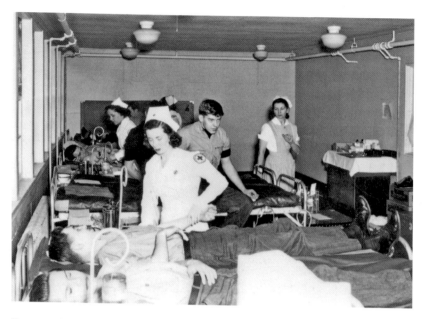

Recuperating soldiers are helped by nurses at Thomas England General Hospital in Atlantic City. *Atlantic City Free Public Library.*

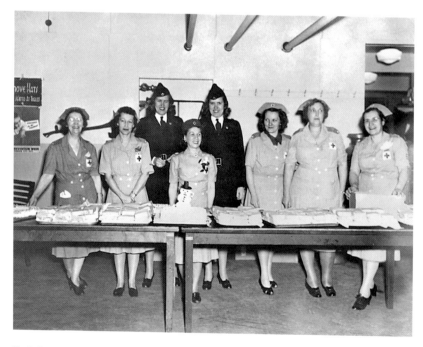

Red Cross volunteers and officers serve food at the Catholic Daughters dinner for soldiers. *Atlantic City Free Public Library.*

deemed necessary. The canteen corps provided food and drink to patients on various occasions, and the production corps volunteers made products for the soldiers by sewing and knitting.

The Camp and Hospital Service was another vital branch of the Red Cross. During World War II, the Atlantic County chapter sent many volunteers to the England General Hospital. Local member organizations included the Catholic Daughters of America, the Council of Jewish Women, the Girl Scouts of America, the Salvation Army and the Women's Research Club. These volunteers helped in various areas. For instance, the rehabilitation program at the hospital involved exercise and light duty for the soldiers when possible. The beach community was ideal for this. Recovering soldiers were seen playing volleyball or touch football on the sandy beach. Since some soldiers were unable to leave their beds, they required activities that did not involve leaving their rooms. In an attempt to help make these soldiers more comfortable, the Atlantic County Red Cross organized efforts to acquire bed lamps for as many rooms as possible. While basic room lights were available, it was difficult for bed-ridden soldiers to read or write without an additional light source. Since the army itself did not provide these lamps, the Red Cross volunteers jumped into action. With the help of local organizations such as the Atlantic City Kiwanis Club, the Women's Civic Club, the Council of Jewish Women and the Women's Civic Club of West Atlantic City, the Red Cross was able to purchase and present at least one thousand lamps to the army hospital. Another impressive feat was the radio project completed by the Camp and Hospital Service. This initiative wired the England General Hospital with around 2,700 headphones to be used by patients.

Red Cross women traveling abroad did not have an easy time. As Eleanor Stevenson recalled, "Red Cross girls with club-mobile units and evacuation hospitals in the forward areas live in tents, and I didn't have a real bath from the middle of October until the day before Christmas. During all that time, I washed in a helmet." The women often put the needs of the soldiers first, eating last at the chow line. Their bravery was well known, especially as they continued to do their duty close to the front lines. Sometimes volunteers were simply there to listen to the problems of the soldiers, from concerns about girlfriends and wives back home to apprehension about the dangers of combat.

Marie Griffin, who lived in Hillsdale, New Jersey, volunteered to be a Red Cross aide during World War II. With her already busy schedule, she had to complete Red Cross training after work. The course was six weeks long and was broken down to two evenings a week and Saturdays.

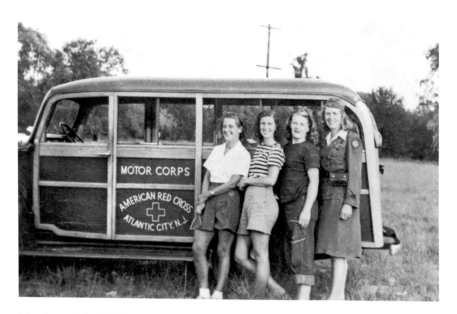

Members of the Red Cross Motor Corps at a Lake Lenape picnic. *Atlantic City Free Public Library.*

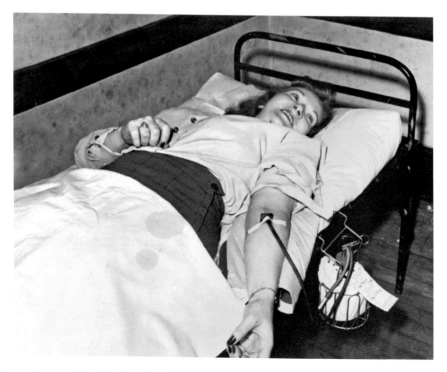

Mary Hackney donating blood for the war effort. *Atlantic City Free Public Library.*

Once she completed training, she worked her regular job and then served as a Red Cross aide at the Columbia Presbyterian Medical Center two nights a week and one day during the weekend. She said, "So that was time consuming. It was also interesting. I learned to do a lot of nursing routines. As Red Cross Nurses' Aides, we did all nursing chores, but were not permitted to dispense medicines." Marie was transferred from the medical center and then worked at the Red Cross blood bank. Her job was to help the nurses check the blood of the donors. Mostly, Marie kept watch over the people who gave blood, giving out refreshments and making sure they did not pass out and hurt themselves.

THE GRAY LADIES

During World War I, the Red Cross started using a system of color codes to determine the duties of the different volunteers. The Hostess and Hospital Service and Recreation Corps, founded in 1918, was one example of this system. Since the members of this group wore gray uniforms with white cuffs and collars, they soon earned the nickname the Gray Ladies. In 1934, the official name was changed to the Red Cross Hospital and Recreation Corps. However, the nickname used by soldiers was so pervasive, that in 1947, they were officially recognized as the Gray Lady Service. These female volunteers were involved in nonmedical tasks such as organizing recreation for wounded soldiers. They received training in hospital organization, psychiatric care and occupational therapy. It is estimated that around fifty thousand women served as Gray Ladies throughout the United States during World War II. They staffed hospitals all across the Garden State, even those attached to military bases.

The women of this group may not have performed any specialized medical care, but the emotional support they provided for soldiers certainly won them a special place in the hearts of many veterans. The Gray Ladies filled some strange requests by the soldiers recovering in Atlantic City. One woman took care of a soldier's pet pigeon while he was convalescing in England General Hospital. In another instance, a volunteer made a giant checkerboard for two patients who wanted to play but could not sit in the proper positions due to their injuries. The volunteer hung the board on the wall and moved the pieces herself at the instructions of the players. While these stories might seem strange, completing personal requests were just

A front view of the U.S. Army Hospital at the Raritan Arsenal in Metuchen, New Jersey. *U.S. National Library of Medicine.*

one example of the work performed by the caring volunteers who made up the Gray Lady Service. From simple acts like helping injured soldiers tie their shoes to more difficult requests such as finding bananas for patients during the shortage, the Gray Ladies answered the call to help with amazing ingenuity and enthusiasm.

Calls for volunteers for a Gray Ladies Corps at the Camp Kilmer Hospital were published in Woodbridge newspapers in 1942. Members of this group read to injured troops and provided care for their emotional well-being. An article in a Woodbridge newspaper warned possible volunteers, "The responsibilities of a Gray Lady aren't among the activities that can be squeezed in between a bridge luncheon and tea. Women who enroll through Woodbridge Chapter must agree to serve a minimum of 50 hours a year on a regular schedule. They must take a prescribed training course given by hospital and Red Cross staffs." The article was meant to entice women to volunteer but weed out those who were not dedicated. The women of the Gray Lady Service needed to be willing to put the needs of the soldiers first.

The soldiers, in turn, recognized the importance of these volunteers. As the following story relates, some young military men even viewed

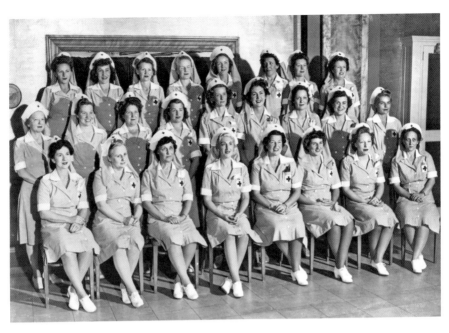

A Red Cross Gray Ladies group photograph. *Atlantic City Free Public Library.*

them as metaphorical angels. A Gray Lady serving at Camp Kilmer in October 1942 told the following story to a Woodbridge newspaper.

As she enjoyed her lunch at Camp Kilmer one day, a soldier asked, "Gee, are you eating?" The woman replied, "Why of course. Why are you asking?" The soldier joked, "I didn't know that angels ate." The article concluded with this telling statement: "But all joking aside, that's what the boys in Camp Kilmer Hospital think of the Gray Ladies who give of their time and efforts to make them comfortable—in fact do everything for them their mothers would do if they were with them." Since many of the soldiers were barely adults, a little "mothering" went a long way during the war.

All told, the help provided by the "Red Cross Girls" was instrumental in the war effort. About seven thousand women served with the Red Cross overseas. These women set up makeshift traveling kitchens to deliver coffee and doughnuts to the troops, sometimes marching right up to the front lines. They drove club mobiles in teams, traveling through combat zones and right into encampments. During the course of the war, twenty-nine Red Cross women died volunteering overseas. Throughout their service, the women of the Red Cross were trained to put the needs

of the soldiers first. Their record of selflessness on the homefront and overseas during World War II continues to attest to their strict adherence to this mission.

THE ARMY AND NAVY NURSE CORPS

If I were young enough, I would rather be a nurse in the Army or Navy, for they are allowed to share more nearly the men's existence. They know that there will be no attitude on the part of the boys which says "Oh yes, you have come in to wear a uniform, but you don't really mean ever to do a job which will inconvenience you or change the ease we men are expected to provide for our women."
—Eleanor Roosevelt

On a warm afternoon in the shore resort of Atlantic City, New Jersey, men walked up and down the flat boardwalk. With the salt air breeze in their hair, they stretched their muscles and did some light exercises. While it sounds normal enough for a beach community, the reality was anything but that. These men were actually soldiers recovering from injuries sustained while fighting overseas. Their injuries ranged from broken bones and gunshot wounds to amputations. In fact, during World War II, many amputees learned to use their prosthetic limbs on the boardwalk in Atlantic City. The Thomas England General Hospital became the center of recovery for many soldiers. With such a massive job ahead, the hospital needed nurses and Red Cross volunteers to care for the returning military men.

Unlike many of the other women's service branches, the army and navy nurse corps were not an invention of World War II. In fact, the army nurse corps was officially created in 1901 and the navy nurse corps soon followed in 1908. Originally, these women were considered civilians working with the military, but after their two decades of service, the U.S. Army finally recognized their invaluable roles by allowing them to earn military ranks in

Amputees exercise on a sun deck at the Thomas England General Hospital in Atlantic City, New Jersey in 1945. *U.S. National Library of Medicine.*

1920. Of course, the nurses of both branches were far from equal to military men at this point. As with the men of the army and navy, nurses could be required to serve overseas. They also worked in military hospitals on the homefront. With a large influx of injured soldiers being transported back to the United States, the need for local nurses increased as the war progressed. In fact, there was a massive shortage of nurses in the early 1940s. In response to this need, the U.S. Congress passed a bill offering college tuition to any young women willing to join the nurse corps. In June 1943, Public Law 74 established the Cadet Nurse Corps under the leadership of the United States Public Health Service.

The national need for recruits naturally spurred a government recruitment drive. Posters urging young women to serve their country by becoming a nurse joined the plethora of other wartime drives targeting women. New recruits were required to take the following pledge, "In consideration of the training, payments, and other benefits which are provided me as a member of the United States Cadet Nurse Corps, I agree that I will be available for

A look inside the dental clinic at Tilton General Hospital in Fort Dix, New Jersey. *U.S. National Library of Medicine.*

military or other federal, governmental, or essential civilian services for the duration of the present war." As the war progressed, more injured soldiers began filtering back into the United States for care. The need for nurses was urgent. An advertisement in a local newspaper stated, "Never before in America's history have her young women had the opportunity to be of such great service to so many." Patriotism inspired women across New Jersey to respond to these calls for action.

As with other military women, the army and navy nurses went through basic training before being sent to a duty station. For army nurses, this included instructions on seeking foxholes for cover, dealing with gas attacks and purifying water. Nurses often went where the fighting occurred. During the attack on Pearl Harbor, there were eighty-two army nurses already stationed there. On that fateful day, nurses tirelessly attempted to help the injured.

Annis Weir, of Trenton, New Jersey, was a navy nurse during World War II. Since she lived in Trenton, she trained at the Saint Francis Hospital, which was located across the street from her high school. Her hospital training

involved six weeks of classes and six weeks of training on the patient wards. Night duty was an exhausting twelve-hour shift for six weeks. Growing up during the Great Depression, Annis was familiar with hard times. Perhaps this prepared her for the trials she faced as a nurse during the war years. She completed her training in 1943 and went to work at Mercer Hospital shortly afterward. At this point, the war had been raging in Europe for years, and the United States had already entered the fray. The mood among her and the other nurses was one of resignation. They believed that they would be called to duty soon. Seeing ill patients and feeling emotionally attached to them was difficult. Some of the battlefield wounds were hard to look at. She treated prisoners of war who had returned from imprisonment, emaciated and ill. She said, "I just felt it was something I had to do and I wanted to do, and I did it." Despite the emotional difficulties and the physical demands, Annis looked back on her time as a navy nurse with pride. She said, "I look back on it as time well spent, and I'm glad I did it, and I'd do it again."

Jessie Watt McIntyre served as a nurse in the army nurse corps from 1943 to 1946. Originally from Collingswood, New Jersey, Jessie went to school for nursing immediately after high school. After joining the service, she completed basic training at Fort Jackson, South Carolina. This training included preparation for duty overseas. The young recruits learned to dig foxholes, navigate through areas wearing gas masks and set up tents. They also learned that there were many more uses for their helmets besides protecting their heads, including washing their hair and heating up soup. She came back to New Jersey to work as an operating room nurse at Fort Dix for a while. Her time there consisted of living in barracks, working a shift in the wards and then coming back to the barracks. In 1942, she was sent to England on the *Queen Elizabeth*, a large passenger ship that was converted to transport troops during the war. She recalled the intense bombing campaign in England: "I spent just one night in London, and that was enough, I'll tell you. To hear those things coming, and you never know where they're going to land. A couple did land near where we were staying, shook the building, I remember, and it was a terrible feeling." After a harrowing first night in London, she was soon sent to France and then Germany.

A few other instances stood out in Jessie's mind, even decades later. While traveling through war-torn Europe, Jessie and the other nurses received a booklet with instructions on what to do if they were caught by the enemy. Laughing, she explained, "Well, I guess we felt less secure after we got that." Another instance that was forever etched in her mind was being part of the group that liberated the Mauthausen Concentration Camp in Austria.

Many of the camp prisoners were far beyond help by the time American forces arrived. Aside from being starved, the prisoners they found suffered from typhus and tuberculosis. Without proper food supplies to deal with starvation and diseases running rampant throughout the camp, the nurses watched as countless people died after liberation. They were unable to get supplies for the first few weeks, so they went to the country to scrounge up any food they could find. Jessie recalled, "So there was very little we could give them. We had brown bread that was made locally, and ersatz coffee or something. But we really didn't have the proper food for them for a week or so, and many of them died in that time, of malnutrition and, as I say, typhus." Nurses attached to groups that liberated concentration and death camps were some of the first Americans to bear witness to the atrocities of the Nazis.

Another nurse, who spent much of her youth in Cranford, New Jersey, was Bertha Nichols McClure. She joined the army nurse corps in 1944 and completed training in Atlantic City, New Jersey. At that point, the city had already been converted for military use. Bertha went through basic training that included crawling through foxholes and going on ten-mile hikes in full gear. After that, she served in the Pacific theater. As with other nurses who dealt directly with wounded soldiers, she recalled that one of the most difficult parts of her job was the death of patients. While in Iwo Jima, they were bombed by the Japanese frequently. When this happened, the nurses were ordered to retreat to the safety of the caves.

Nurses serving overseas comforted soldiers because they represented a little taste of home. Soldiers who ran into nurses in combat often bombarded them with questions about the homefront. On October 21, 1944, a soldier's letter to *Stars and Stripes* read:

> *To all Army nurses overseas:*
> *We men were not given the choice of working in the battlefield or on the homefront. We cannot take any credit for being here. We are here because we have to be. You are here because you felt you were needed. So, when an injured man opens his eyes to see one of you...concerned with his welfare, he can't but be overcome by the very thought that you are doing it because you want to.*

Nurses served both on the homefront and abroad during the Second World War. In 1944, a letter from Lieutenant Carlette S. Seemuller of the U.S. Army Nurses' Corps read, "Yesterday, we had an increase during the

A cadet nurse class poses at Atlantic City Hospital in September 1942. *Atlantic City Free Public Library.*

night and started the day with a bang. We filled their hungry mouths with food then started scraping off the dirt." She went on to describe cleaning a ward with over fifty beds after tending to the wounded soldiers. It seemed her work was never truly done. Despite the seemingly endless tasks before her, the young nurse's letter contained no trace of complaint. Instead, she spoke with pride about playing a part in the war effort. "It has all been worth it," she wrote. Even when faced with less-than-cooperative soldiers, she stayed positive. "Recently, I learned another trick. We get some seemingly smart 'Alecs,' but just feed them, get them clean, take off the beard and you have an angel. Can you imagine a soldier as an angel? Neither can I, but you get the general idea."

The affection shown to these women by soldiers is evident in the many letters printed in local New Jersey newspapers throughout the war years. In one example, a soldier who spent three months in an Italian hospital after getting jaundice on the front lines wrote to a nurse. After encountering a nurse from Asbury Park, New Jersey, he wrote, "On behalf of our boys in this room I dedicate this poem to our favorite nurse to show our appreciation for the work she has done to get us back in shape and well again." An excerpt from his poem was printed in the *Red Bank Register* in March 1943.

Our Favorite Nurse
Few days ago we heard the news
That our favorite nurse was leavin'
We can hardly bear to hear this, but
Seein' is believin'
The boys here in this room will
Forever respect your kindness:
Your spirit was always in bloom,
With never a moment of sadness…

By the time Victory in Europe was officially declared on May 8, 1945, over 59,000 army nurses served both overseas and on the homefront. All told, the war had cost the lives of 201 army nurses, 16 of whom were killed by the enemy. Over 11,000 women had served in the navy nurse corps. Many nurses were decorated for their bravery. Above all, they demonstrated a desire to help and a willingness to endure long hours, physical exhaustion, exposure to disease, hostile environments, emotional trauma and the possibility of capture. According to the army surgeon general during World War II, "There isn't one at the front who would quit if she could. Not a nurse has been returned from the fronts who hasn't begged, sometimes with tears in her eyes, to go back." For many nurses, their job was not done until all the soldiers came home.

"ARE YOU DOING ALL YOU CAN?"

OTHER HOMEFRONT EFFORTS

Whatever our individual circumstances or opportunities—we are all in it, and our spirit is good, and we Americans and our allies are going to win—and do not let anyone tell you different.
—Franklin Delano Roosevelt

Traditionally, the attack on Pearl Harbor is viewed as a turning point in history. The tragic loss of life suffered at the base in Hawaii galvanized public opinion in favor of American involvement in the war. While it is a well-known fact that Pearl Harbor spurred many young men to volunteer for military service, the homefront activities of women also kicked into high gear. For many New Jersey women, full-time employment was no excuse for not doing their bit for the war effort. Women tasked with providing for their families needed employment. However, many were still struck with the desire to help in some way. Pat Witt's mother was one of the women who worked tirelessly during World War II. Once her day job as a teacher ended, she volunteered as a plane spotter. Other women and girls in Millville helped in any way they could. Ms. Witt reminisced, "Then all the women in the town at the local YMCA, they would go every day, afternoon and evenings, and fold bandages. All the women! We were very patriotic here." She went on, "A lot of women who could knit. They would knit. They were given the khaki wool. They made mittens, gloves, hats and scarves…Then they would make boxes for our men overseas. They had a list of everything you could send." The sheer number of people who volunteered for the war effort in some way

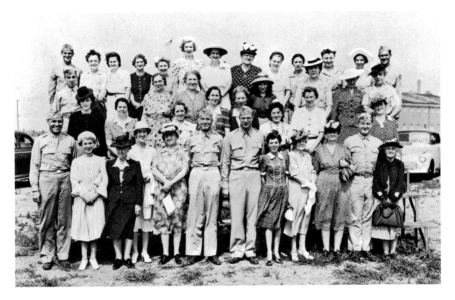

Soldiers happily pose with local "sewing moms." *Atlantic City Free Public Library.*

is both impressive and overwhelming. Many women had multiple jobs or volunteer opportunities in wartime New Jersey. It was not uncommon for a woman to work at a factory or another regular job during the day and then volunteer after her shift. In fact, many women who joined the WAC, WASP or other military branches needed written permission to go if they had a job in the defense industry already. Women involved in wartime volunteerism in the Garden State seemed truly tireless.

Posters littered local businesses and generally anywhere the public would see them. Clever little slogans like "Can all you Can" and "Knit your Bit" along with less snappy ones like "More Production" and "Conserve Fuel" greeted citizens. Purchasing war bonds was considered a patriotic duty. Not only did these vouchers provide financial support for the war effort, but they also helped to fight off inflation by taking money out of circulation. Countless individuals bought war bonds during U.S. involvement in the war, an act made even more impressive considering the desperate financial situation many were in during the Great Depression. In one of his famous "Fireside Chats," President Roosevelt advised, "I cannot tell you how much to invest in war bonds. No one can tell you. It is for you to decide under the guidance of your own conscience." The purchase of war bonds was a statement that we were all in this war together and that, by virtue of our citizenship, we all had a share in America.

Luxury items were not to be purchased. Only the necessities were allowed, and any extra money left was spent on war bonds. New Jersey cities held their own sales campaigns that were ultimately combined to meet state quotas. Usually, bond drives were successful and went above and beyond their quotas. Groups such as the Girl and Boy Scouts of America, various labor unions, businesses, women's clubs and men's lodges went on tireless bond sale campaigns. Schoolchildren marched in bond parades to entice onlookers to purchase more. Throughout the American involvement in the war, about eighty-five million U.S. citizens purchased war bonds in varying amounts. It is believed that nearly half the money needed for the war effort was provided by bond sales.

Other efforts were a little less volunteerism and a little more necessity. Rationing was a very real and sometimes irritating factor in wartime New Jersey. It seemed that many residents simply took these inconveniences in stride. After all, there were much bigger concerns, especially for those with loved ones overseas. Bee Haydu recalled, "People were more patriotic. There was rationing and you just adapted to it. Sons and daughters were off to war, so there was always a lot of concern about that." The need for conservation was also pressing and was created by several factors. The pressure of a world war affected imports and exports of goods by sea. Those goods that were manufactured in factories on American soil were becoming scarce as industry converted to wartime production. Automobile manufacturers turned their gaze to making planes and jeeps for the war effort. Products that were readily available in the time before World War II were no longer being manufactured. Common items like material for clothing were being used for military purposes. Sugar and butter shortages hit people particularly hard. Often the anticipation of a shortage caused a mad rush to the store to stock up. Women were encouraged, albeit strongly, to reuse clothes instead of buying new ones. Women were advised to be more self-sufficient. Posters urged them to plant victory gardens, can food and pack healthy lunches for the defense industry workers in the family. "Food is a Weapon—Don't Waste it," advised one poster. Salvage habits were developed quickly. Everyday items like tin, batteries and paper became essential. Even the fat from cooking was saved and used for ammunition.

Women volunteered for the Office of Civilian Defense (OCD). Founded in May 1941, this organization was responsible for the mammoth task of coordinating homefront volunteers. From this umbrella organization, local defense councils emerged. Those councils planned activities, helped to place volunteers in positions and even provided training. Without

this organizational dimension, homefront volunteerism may never have expanded at the rate it did during World War II. In response to a shocking deficit in available farm labor, the U.S. Department of Agriculture created the Women's Land Army. Volunteers traveled from all over the country to work on farms. Many of these women came from cities and had no experience with farming whatsoever. As in other areas during the war, these women proved themselves and converted many skeptics by virtue of their tenacity and willingness to learn. Many farmers applauded the efforts of these volunteers.

Women joined their own defense leagues to help organize emergency response and preparedness in their communities. Aside from the obvious bond contributions, people were encouraged to donate to the Red Cross, local hospitals and USO clubs to keep them running. Girls volunteered to help in their schools and with groups such as the Girl Scouts. June McCormack Moon, born in Lakewood, New Jersey, helped the war effort through her local Scout troop during the war. The girls rolled bandages for the war effort and learned to identify different types of planes. In New Jersey, the level of participation on the homefront was pervasive and truly permeated every age group.

CALLING ALL WOMEN

THE AMERICAN WOMEN'S VOLUNTARY SERVICES

*Every club woman should be willing to volunteer, whether it be in rural program
work, aircraft warning service, office work, the motor corps, the nurses' aide
program, air raid patrol centers, nutrition, house registration, checking citizenship
records, education programs, home gardening, first aid, or home nursing. There is
something that each one can do.*
—*Mrs. Gustav Ketterer*

*Every woman can serve humanity in this war. The task falling upon us requires the
concentrated efforts of not just a few, but rather the combined efforts of many women.*
—*Mrs. Whitney C. Leeson*

The National Defense Department called on the women of the nation
to fully immerse themselves in support efforts to win the war. They
were to buy war bonds; entertain servicemen through social events, such as
dances or even having a few servicemen over for a home-cooked meal; serve
as air raid wardens; volunteer in sewing rooms; learn to farm and conserve
food; reuse fabric to make clothes; and promote education on American
values and democratic principles. Women were called on to help in virtually
all areas of society. The American Women's Voluntary Services (AWVS)
formed on a national level well before the United States officially entered
World War II.

Founded in January 1940 by Alice Throckmorton McLean, the AWVS
soon became the single largest woman-powered service group in the country.
McLean was inspired by Britain's Women's Voluntary Services group. The

Members of the American Women's Voluntary Services Motor Transport. *Atlantic County Historical Society.*

organization was created with the main goal of preparing the nation for war in any capacity necessary. With such a broad mission, it was not surprising that the campaigns of the AWVS were so diverse and far-reaching. The AWVS served to place volunteers into positions within their own groups and other volunteer associations like the Red Cross. Any woman over the age of eighteen was eligible for membership and all of these women were fingerprinted and given a membership card. Volunteers served in a variety of posts, including but not limited to transporting groups of military personnel, organizing clothing drives, keeping up troop morale, organizing activities for hospitalized soldiers, selling war bonds and collecting scraps. In actuality, the work performed by the AWVS was sometimes similar to that of other volunteer organizations, especially the Red Cross.

According to a brochure printed by the New Jersey AWVS state headquarters in Newark, women could expect to be trained in any number of areas, including air raid precaution, child care, fingerprinting, canteen, victory gardens, canning, map reading, home repairs, mechanic work, war

photography, physical fitness, maternity aid, switchboard operation and office aid. The brochure went on to state, "The AWVS is a permanent national organization created in anticipation of the part that American women can play in protecting their homes and serving their country and communities." In a January 1942 article, *Time* magazine noted, "Of all the volunteer groups, the one that made the most noise was the American Women's Voluntary Services." McLean was present in New York during the first air raid alarm. Although it turned out to be a drill, she was determined to remain ready in case her services were needed. She vowed: "We shall remain on duty for 24 hours. Our Motor Corps and emergency kitchen will be drawn up outside the door ready to rush to any spot where there is a disaster. I have sent women downtown to hunt for tin helmets, and others are sewing armbands on their uniforms. I shall stay here all night."

In the national AWVS bulletin, author Betty Smith wrote, "I do not see how any woman could selfishly stand aside and do nothing and be happy

A member of the Atlantic County American Women's Voluntary Services drives a navy shuttle bus for the U.S. Naval Air Station in Pomona, New Jersey, in May 1944. *Atlantic County Historical Society.*

living in a country being made safe for her by men in battle and women sacrificing on the homefront. There is so much to do. It is not a woman's privilege to help; it is her solemn duty and her sacred obligation." There truly was a great deal of work to do on the homefront.

While the nerve center of the AWVS was located in bustling New York City, the group soon expanded throughout the United States. Within two years, the organization boasted 350 chapters nationally. The women of the AWVS of New Jersey answered the call with vigor and enthusiasm. Headquartered in Atlantic City, New Jersey, the Atlantic County unit of the AWVS formed a network of services that effectively mobilized Garden State volunteers for the war effort. One of the early AWVS plans involved training women to fight fires in case areas of the United States were ever bombed. This was based on similar services offered by women's volunteer organizations in Britain, where the bombing of cities occurred regularly during World War II. The AWVS conducted disaster preparedness drills to ensure efficient response to any local emergencies. For instance, in 1941, the Harding Township chapter of the AWVS conducted a drill where volunteers learned to deal with a mock emergency. The women set up a mobile kitchen to feed the "victims" and a four-bed ambulance to render first aid. The women received a full ten weeks of instruction on how to run the mobile kitchen successfully. The mobile units were organized into teams of five to seven people, including a captain, a driver, kitchen workers and at least one person certified in first aid.

The Atlantic County Unit was especially active during the war. Located on Atlantic Avenue in the busy community of Atlantic City, the unit was officially formed on June 25, 1943. The early committees in the unit were the Motor Transport and the Guide Services, but more soon followed. Local volunteers were fingerprinted and given identification cards. From used clothing drives to driving soldiers back and forth, the Atlantic County unit was involved in a variety of important tasks. Volunteers organized fashion shows to demonstrate what women could create with old fabric. Members hit the streets en masse collecting tin cans to use for packing blood plasma. Leather bags and costume jewelry were repurposed for military use. Since war readiness required massive quantities of metal to manufacture tanks, ships and other items, any type of scrap metal was gathered for the war effort. The sewing unit used volunteer knitters and seamstresses to supply members of the armed forces with socks and sweaters. Volunteers made their presence known on the Atlantic City Boardwalk with practice marching drills and parades. Members also provided recreational activities and donated items for local hospitals and helped to recruit women for military auxiliaries. The

Members of the American Women's Voluntary Services Guide Service. *Atlantic County Historical Society.*

Motor Transport volunteers helped to staff the library at the Atlantic City Naval Air Station in Pomona, New Jersey. Members received instructions on library procedures and even donated their own magazines.

A headline from the *Atlantic City Press* boasted, "Women Collect 8594 Pounds of Paper." The article went on to specify that the Salvage Committee of the AWVS was responsible for collecting the scraps in a short sixty days. Former county salvage director and Somers Point mayor, Fred W. Chapman, applauded the efforts of the volunteers, stating, "This is an interesting achievement and deserves much commendation." He went on to explain that the paper collected would result in the creation of "17,198 Red Cross Blood Plasma boxes." Clothing drives were another significant part of the war effort in New Jersey. The Atlantic County AWVS collected clothing to send to the impoverished people in countries occupied by the Axis powers. The Clothes Conservation Campaign slogan, "Sew, Serve, Save," called on women to remake clothes instead of making new purchases and to reuse any old fabrics instead of throwing them away.

Keeping morale up was also a concern of the AWVS. The Victory Pastime Committee was in charge of providing injured servicemen with gifts to keep them occupied during their recovery. Members of this committee presented convalescing soldiers with musical instruments, magazines, crossword puzzles, board games, card tables and phonograph records. What might seem small to some was greatly appreciated by many members of the armed services. In a letter to the AWVS of Atlantic City in January 1944, John W. Bishop (first lieutenant, MAC public relations officer) wrote expressing his heartfelt gratitude for the card tables and games the organization had donated for the recreation of the soldiers. He said, "It is not necessarily the articles that are donated, but the thought behind such donations that makes these patients realize that while they are convalescing from injuries inflicted by the enemy, they are not forgotten men, and that all those who have stayed at home will never forget the job they have done." Many times, being reminded that people loved and appreciated them on the homefront was the inspiration a soldier needed.

A member of the Atlantic City unit of the American Women's Voluntary Services provides motor pool services. *Atlantic County Historical Society.*

The drive and leadership at the head of the AWVS was instrumental during the war years. Mrs. Ogden L. Mills, founder of the AWVS War Shop, wrote the following about Alice T. McLean: "It took a woman of great vision to start an organization that today commands the attention of the entire country. By her genuine belief in the necessity of mobilizing the woman power of this country, and her understanding of human nature, today we represent voluntary service in its truest meaning." First Lady Eleanor Roosevelt echoed these sentiments on the importance of volunteerism in her *Ladies' Home Journal* column "If You Ask Me." In May 1941, a nineteen-year-old woman asked Roosevelt what she should be doing for the war effort. Roosevelt replied:

> *Another important reason why girls should give a year of service to our country is that through so many years we have been constantly increasing our placid acceptance of what the men in our country provided, and that frequently includes their participation in government and their defense of us in wars. Wars today are back where they used to be, and women stand side by side with the men.*

Impressively, during a time when segregation was still legal and discrimination based on ethnicity and gender was still prevalent, the AWVS attempted to be inclusive in its membership. The organization welcomed members from various backgrounds. The AWVS also had a junior membership with specific tasks and initiatives. New Jersey's junior volunteers sold war bonds, delivered information fliers and books, collected scrap paper and metal, hemmed sheets for hospitals, took photographs of servicemen and much more. The AWVS encouraged them to pursue careers like social work or nursing when they reached adulthood. In an issue of the AWVS national bulletin, Florence Hollis wrote, "One of the things the war has taught a lot of Junior and Senior AWVSs is the real pleasure that comes from doing a job that is really worth doing as well as interesting."

As with other volunteer organizations, the AWVS contained many different committees. The Atlantic County Salvage Committee, formed in October 1943, began its work with a campaign to collect used clothing for the National Used Clothing Drive. The initial campaign was a success, with volunteers gathering an estimated ten thousand pieces. Furs were collected to make insulated vests for the Merchant Marines, and volunteers collected scrap paper weekly. By February 1945, the Salvage Committee had collected nearly fourteen tons of paper for the war effort.

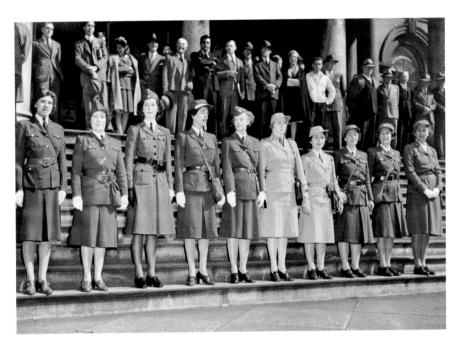

Members of the American Women's Voluntary Services pose proudly. *Photograph by Bill Schiff; courtesy of Library of Congress.*

During World War II, the Milburn AWVS unit published a monthly newsletter called the *Township Tattle*. The publication was another example of keeping up the morale of the American public both on the homefront and abroad. A large portion of the publication was dedicated to good-natured reports on local members of the armed forces. Copies were even sent to troops stationed around the world who were encouraged to write letters to the staff. Those volunteers in turn detailed the highlights in the paper with upbeat and comical commentaries. For instance: "H.B. Gallison S 2/c (R.M.) is at present exposed to southern hospitality near Norfolk, Va. and could probably stand meeting a few local WAVES himself. Bailey says all he's seen are lots and lots of sailors with civilians outnumbered seventy-five to one; but even with such depressing odds we'll bet on you to get a nice date anytime."

In another report, the *Tattle* joked, "Pfc. Joseph M. Pepe of the Marines is still at the same old spot doing the same old job as when he last wrote us." Another article stated: "After thirty-two months of duty in the South, South-west, and Central Pacific areas, Col. Worden has been assigned to headquarters in Washington, D.C. Not that that isn't impressive but what

throws us into a tizzy of happy satisfaction is that we apparently appeal to him enough for him to give us his new address."

Women who were on duty were also encouraged to write in. Among the many personal stories concerning active duty women was a letter from a Red Cross volunteer stationed in Italy. According to the *Tattle*, "Our sides are a mass of embroidery as we read about her trials and tribulations when she discovered upon her arrival that skirts were taboo and slacks were the order of the day (and night!)."

The AWVS also published booklets contained useful tips on how to cut fabrics and take measurements, information on clothing conservation courses and pattern examples. The importance of this conservation in wartime was made clear in a letter from the War Production Board written to the vice-president of the AWVS of New York on April 29, 1944. The letter stated, "The voluntary Conservation Program of your organization designed to conserve textiles through re-making discarded garments, appeals to me as a splendid example of the ingenuity of American women."

The AWVS continued its campaigns after the war was over. Realizing the need for rehabilitation for the returning military, some of whom were injured, leaders of the AWVS made plans to help. In an early campaign, the national AWVS announced that it would train volunteers to teach photography as part of the navy's rehabilitation program. The organization's Photography Division was in charge of this effort. The Vocational Counseling Service aimed to help the many women who volunteered in military branches or in defense jobs to smoothly reenter their communities once the war was over.

"LET'S KEEP 'EM SMILING"

THE UNITED SERVICE ORGANIZATIONS

There are many things, of course, which can be done to raise Army morale. One is to make sure that the families at home are well cared for by the communities in which they live. Another is to see that the communities near the camps take an interest in the boys in camp and give them some kind of home atmosphere. Also, I think it is important that the home community continue to have an interest in the boy, even when he is in camp.
—Eleanor Roosevelt

It all started with a call to action issued by a very powerful man. In 1941, with Europe in turmoil, America was preparing for war. The USO was officially formed in response to a request from President Franklin Delano Roosevelt that people on the homefront take responsibility for the recreation of soldiers. The president lauded the importance of recreation in the war effort, emphatically stating, "Entertainment is always a national asset. Invaluable in time of peace, it is indispensible in wartime." The volunteers of the United Service Organizations went to great lengths to ensure that the men of the armed forces felt cared for. Women in the USO volunteered for a variety of social activities to boost the morale of the troops, including playing cards or board games, dancing or singing. The first official meeting of the organization was held on April 17, 1941. Financed by the charity of the American public, the USO was formed to ensure the men of the armed forces were not forgotten on the homefront. Once women joined the military, these services were extended to them, as well.

With this goal in mind, the USO was made up of six agencies: "the International Committee of Young Men's Christian Associations, the National Board of Young Women's Christian Associations, the National Catholic Community Service, The Salvation Army, The National Jewish Welfare Board, and The National Travelers Aid Association." Although the government never officially funded the USO, the group operated under the guidance of the U.S. Army and navy. President Roosevelt was the first honorary chairman of the organization. Since the USO was a nonprofit organization that relied on donations to function, local clubs used any economical building as a headquarters. From churches to museums, USO clubs sprang up rapidly.

According to the constitution of the USO, volunteers were "to aid in the war and defense program of the United States and its Allies by serving the religious, spiritual, welfare, and educational needs of the men and women in the armed forces and the war and defense industries." Serving the needs of the armed forces meant many different activities, from helping soldiers write letters to playing board games with them. Within a few short years, USO groups operated in three thousand locations throughout the United States.

At USO chapter headquarters, the smell of freshly made coffee and sugary snacks welcomed soldiers in the early hours of the day. The USO had volunteers all over the United States during World War II. These women, officially called "hostesses," were far more than that to many soldiers. They were moral support, a taste of normalcy in a world turned upside down. The junior and senior hostesses of the USO provided services that might seem mundane to the average onlooker. They brought homemade treats to soldiers, served coffee and provided a friendly ear to listen. These women, who donated countless hours of their personal time, helped these soldiers to find a sense of home in an otherwise violent and uncertain time. They took nurturing out of their own homes and away from their families and brought it to the men of the armed forces. USO hostesses were expected to expand on their roles as caretakers. As was common in the home, there was a division of responsibility based on age and experience in the USO, as well. Usually, senior hostesses were married women in their mid-thirties and older. They often took on the added responsibility of counseling soldiers who were homesick. The younger members, or junior hostesses, engaged in activities that involved socializing with the soldiers. Providing a sense of home life for the troops was an essential part of USO work. Hostesses attempted to direct soldiers away from bars and to a more wholesome recreational experience at the USO.

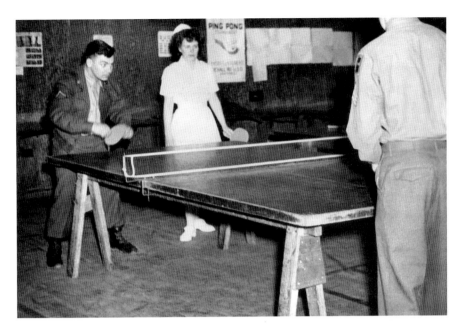

Playing Ping-Pong at the USO in Fort Dix, New Jersey. *James Marker.*

Perhaps the most well-known effort of the USO consisted of the famous Camp Shows. Beginning in 1941, these events supplied live entertainment for troops with the help of USO hostesses and famous entertainers. Celebrities visited the Garden State to entertain troops before embarkation. Once American soldiers began deployment, USO shows traveled overseas with them. A Victory Books campaign, undertaken by the USO and the Red Cross, distributed around ten million books to members of the armed forces. According to Dwight D. Eisenhower:

> *The USO has given an impressive demonstration of the way people in our country of different creeds, races, and economic status can work together when the nation has dedicated itself to an all-out, integrated effort. The people at home occupy a strategic place in a nation at war. One of their major responsibilities is to convince the armed forces that the country is behind them.*

In New Jersey, the USO certainly accomplished Eisenhower's goal with fervor. The overwhelming activities of local USO units provide a truly impressive record. Founded in February 1941, the Red Bank USO of

Monmouth County provided entertainment on both a small and large scale. From weekly visits to keep local troops company to major parties, hostesses in this region truly had their hands full. The holidays were especially busy for volunteers. During the Christmas formal, hostesses carefully planned activities and tirelessly gathered supplies. According to the *Red Bank Register*, the Christmas celebration was attended by over two hundred hostesses and about seven hundred servicemen. As Bing Crosby's "White Christmas" bellowed out over the dance floor, servicemen and hostesses danced and chatted. Young women walked quickly from one chore to another, bustling around serving punch and sandwiches. Talented volunteers performed dance and musical numbers.

With an eye on recruitment, the Red Bank USO frequently held informational events. By February 1944, over one thousand volunteers had donated their time to the USO every week. As an international organization, the morale of servicemen was always in the forefront of USO efforts, and the Red Bank hostesses were no exception. A newspaper account presented a busy picture of the Red Bank USO: "Informal dancing, Sunday afternoon coffee hour and community singing, programs of games and other activities are featured. The club is in constant use, and the library, lounge, workshop, dark rooms, bowling alleys, game rooms and canteen snack bar do double duty every day." Another service offered was a Camera Club to provide photos for servicemen.

In the 1940s, a popular USO slogan was "You help someone you know when you give to the USO." Fundraising was a big part of keeping the USO running. In New Jersey, each township carried out a campaign working toward the state goal, which was in turn collected by the state committee headquarters located in Newark. In May 1942, the New Jersey fundraising quota was $1,572,500 of the national goal of $32,000,000. Impressively, all the counties in the state participated.

The Millville USO was another local chapter dedicated to providing wholesome fun to soldiers. In 1942, an American Legion building located on Main Street was utilized for the USO. Young women volunteered to be hostesses, running social gatherings with food, nonalcoholic drinks and entertainment. Young men training at the Millville Army Air Field arrived at the Millville USO by bus. The room also included a piano, card tables and a phonograph. Patricia "Pat" Witt of Millville, New Jersey, was involved with the local USO from an early age. Exactly how she joined these volunteers was a story of being in the right place at the right time. When Pat was a senior in high school, she played basketball at the local YMCA. One day,

a group of soldiers just happened to be using the gym, as well. She fondly recalled the young soldiers asking the director of the USO why Pat was not a USO hostess. As fate would have it, the director agreed with the soldiers, and Pat soon became a volunteer.

Of course, the USO was not all fun and games. Pat vividly recalled the rules of the Millville USO. Volunteers must wear appropriate clothes at all times. They could not wear any tight-fitting clothes or short dresses. Dating the soldiers was forbidden (although this inevitably happened). They were required to volunteer for at least eleven hours per month. For the Millville chapter, trips to the sunny beaches of Ocean City, New Jersey, were a must. The headquarters was always open until at least ten o'clock at night. Volunteers danced, played piano and challenged the soldiers to Ping-Pong matches. According to Pat, "Our job was to keep up their morale. Sometimes they wanted to talk about their families."

The Millville USO organized formal dances at a local church once a month. Hostesses dressed in skirts that stopped slightly below the knee, wearing bland, solid colors socialized with servicemen in their well-pressed khaki uniforms. As the night progressed, people flooded the dance floor, doing the lively Jitterbug or the Lindy Hop. Pat reminisced, "There was always food, good food for the soldiers. It was a mystery who provided all this food." With rationing kicking into high gear, it was a wonder that these volunteers managed to throw together these social events so frequently. Many women simply used their own ration cards to purchase ingredients for homemade food to bring to the soldiers. While food shortages made providing meals difficult, gas rationing made traveling tricky at best. Pat remembered that recreation was always an issue when local enlisted men came home on leave. Since her family owned a farm, they always had gasoline ready for their tractors. Her friends would call her up on their weekend pass and ask if she would like to go to Ocean City. When she said yes, the next inevitable question was whether she had any gasoline to spare. She joked, "I always had dates because I had gas."

Westfield, a fairly populated town in Union County, also boasted a sizable USO club. According to census records, Westfield had nearly 18,500 residents in 1940. The Westfield USO arranged social events at both Camp Kilmer and Fort Hancock. Activities included home hospitality visits for soldiers who were released from the hospital, dances and even a beach party at Fort Hancock. Orin V. Earhart, chairman of the Westfield USO, stated, "The extent and mobility of the operations of the USO will be determined by the plans of the Army and Navy, as in the past, and will be flexible

enough to meet any new situation." When asked about the responsibility of the USO after victory, he stated, "For the immediate future, it is abundantly evident that the mission of the USO has not yet been completely fulfilled. But it will be fulfilled, as each volunteer and each member agency of the USO recognizes the commitment to carry through to final completion our responsibility." An advertisement in the *Westfield Leader*, asking for donations to the local USO, read, "And I guess I'd be an expert on what it's like to be bored and lonely, if it weren't for one thing…those USO hospital shows. They've been like a tonic which has helped me forget my surroundings, my troubles, myself." The Westfield USO put together a list of people who were willing to open their homes to entertain soldiers stationed in the nearby areas. The booklets were placed at Camp Kilmer.

In an October 1, 1946 radio address, Harry Truman stated, "And the USO is one of the most notable examples in our day of a generous community spirit which goes beyond hometown boundaries—a spirit which brings the universal hometown touch to millions of service men and women who are far from home." During the war, local USO chapters continued to spring up throughout New Jersey. The Matawan USO of Monmouth County worked tirelessly to support the homefront. In July 1942, the local paper reported that the local chapter exceeded the fundraising quota of $2,000 by raising $2,450. In a Raritan Township newspaper, a former soldier said:

> As a veteran of the last war, I can well appreciate the need for the USO. Give those young boys that are now entering service some of the comforts of home and provide in their leisure moments facilities for entertainment and relaxation that the USO affords. Particularly, medical experience has proven that good morale is a powerful factor in speeding the recovery of those hospitalized veterans now in veteran's hospitals all over the country who are looking forward to the USO shows with its varied talent, an opportunity to forget their wounds.

Members of the New Jersey USO clubs certainly had an impact on their fellow citizens. When asked "Do you think GIs will still need USO in 1947?" a member of the navy said, "You bet they will! I know lots of guys who do just as I do when they have some spare time…They look for that USO sign. Where else can you get such wonderful service for so little?" A member of the Coast Guard answered, "I've just been discharged and I know how much the USO meant to me during my time in service. I've always taken the USO for granted. You just naturally look for a USO when you come to a

strange city." A private in the army replied, "USO was with me from Italy to Okinawa. Those Camp Shows were a godsend to us overseas. I don't know what we'd have done without them." Another member of the navy said, "I know that the fellows still overseas and the guys in hospitals are going to need USO. I really don't see how they could get along without it." With so many social events for the troops, the fact that some World War II couples met at USO get-togethers is hardly surprising. One Absecon member of the army air corps said, "I had met Betty at a USO dance at the Atlantic City High School. We married in March of 1944."

As with other wartime activities, Atlantic City also boasted a thriving volunteer base. The USO was so active in Atlantic City that one unit was simply not enough. The Kentucky Avenue USO unit offered personal shopping services for the soldiers who were too injured to buy their own Christmas gifts. Not only did the hostesses go shopping for the soldiers, but they also delivered the gifts wrapped and ready to be opened by loved ones. The testimony of veterans alludes to fond memories of interactions with the USO hostesses. A member of the WAC Medical Detachment, stationed at the England General Hospital in Atlantic City wrote the following in a thank-you letter to the USO in May 1946: "We want to thank you for all the things you have done for us during our stay in Atlantic City. It's been swell and we really appreciate it. You have done so many little things that mean so much." Another grateful woman, who served as a nurse, wrote, "On behalf of the faculty and students of the Atlantic City Hospital School of Nursing I wish to extend to you our sincere appreciation for the many nice things you have done for our Cadet Nurses and especially the very enjoyable dance that you arranged for Thursday evening at the C.D. of A. auditorium." A member of the SPARs wrote, "I have been intending to write long before this to tell you our appreciation of the supper you served for the SPARs."

The Red Bank USO chapter was extremely active during World War II. The USO formed a Traveler's Aid Service during World War II. It offered its help to both civilians and military personnel. The goal of this particular branch was to help people who were from out of state. Reportedly, the Traveler's Aid Service of Red Bank, New Jersey, helped find living arrangements for twelve thousand in its first year of operation. Volunteers helped people find housing, gave out directions, provided information and paired soldiers with hospitable families who wished to open their homes to them. Red Bank's USO hostesses offered many services and amenities, including a snack bar, photograph services, a club library stocked for the needs of the soldiers, a room where servicemen could write letters home, a package service from

which soldiers could get help wrapping and shipping packages home and music appreciation classes. Many recognized that the work of the USO and other volunteer organizations would not stop once the fighting was officially over. Wounded soldiers needed support when they returned home. At a rally of local USO hostesses from the Monmouth County area, Major D.E. MacKinlay, head of special services at Fort Monmouth, said, "Our job will start when the armistice is signed. We are just practicing now, learning to do the big job that is in store for us."

Some New Jersey women went off to other states to do USO work. Edna M. Newby, who went to high school in Leonia, New Jersey, was a math major at Douglass College. During the war, she volunteered at the New Brunswick USO. She then went to New York City to apply for a paying job with the organization. After training in Jacksonville, North Carolina, she went to Lexington, North Carolina, to start a USO chapter there. Because the military activity in Lexington was minimal, she was sent back to Jacksonville. She described having dances, getting supplies for dinners, mailing letters for the soldiers and many other activities. "I remember, Elizabeth, who was so-called program director, she was supposed to think of things to do," she said. "At Christmas time, I remember, she decided we'd get a big tree and she'd get the fellows to make the decorations to put on the tree, and I can remember this one Marine coming in and saying to her, 'Miss Gilligan, if you ever tell any of these other guys that I am making angels, I'll never come here again.'"

THE CAMP KILMER SWEETHEARTS

In January 1942, construction began on a new camp that would serve as a staging site for soldiers. The camp was located in parts of both Edison and Piscataway, New Jersey. Amazingly, the structures on the nearly 1,500-acre tract were completed a mere six months later. With the urgency of the impending American involvement in World War II, 1,200 buildings were constructed at a dizzying pace. Of these structures, libraries, a hospital, chapels, a gymnasium, theaters and a post office were included. The new base was named Camp Kilmer, in honor of Joyce Kilmer, a well-known poet who was killed in action during World War I. Since it served as a transition point for military men being deployed to the frontlines of Europe, over one million soldiers passed through Camp Kilmer in the 1940s. With its own

baseball, football and volleyball teams, the camp also served the recreational needs of the soldiers. Celebrities such as New York Yankees player Joe DiMaggio and comedian Red Skelton were both stationed at Camp Kilmer during their stints in the army.

With so many young troops passing through Camp Kilmer, the need for morale-boosting activities was pressing. It was no stretch of the imagination that the area hosted a variety of social events, many of which were thanks to the enthusiastic participation of the local USO. Affectionately nicknamed "Camp Kilmer Sweethearts" by the military men, USO hostesses became a staple of the camp. Members of nearby communities soon heard about the legendary eight-hour shows performed by USO members at Kilmer. Local newspapers in Rahway, Union County, advertised the weekly activities sponsored by the USO.

USO volunteerism helped the morale of the women as well. With many men gone, the women left behind were eager for a sense of normalcy. The USO socials provided a way for these young men and women to forget about the war for a short time. Jean Comeforo recalled that her local USO helped ease this sense of loss: "I remember there were so few men left, and I remember that being a big problem, but then along came the USO, so that kind of filled in—the USO and dances at Camp Kilmer, and the girls all got dressed up, and had their social life anyway. A lot of marriages happened at the USO and Camp Kilmer dances." For just a few hours a week, the people of New Jersey could socialize and pretend that all was normal.

Catherine Ballantine, also a USO volunteer, remembered the dances fondly. "Well, they had USO dances here on Albany Street. We would come down to dance or just talk to the soldiers and of course when we went to Dix, or Kilmer, this is what it was primarily." Janice L. Karesh grew up in Newark and attended Douglass College during the war. Viewing it as her patriotic duty, she went to the New Brunswick USO to socialize with the soldiers when she could. She was well aware of the impact the hostesses had on young soldiers. She said, "And I don't know how the army handled it all on their side but, we saw a lot of really young men who probably had never been away from home before and who that cup of coffee and the cookie and a little conversation with someone female seemed to help, so." Often, a kind smile and a sympathetic ear were all the soldiers had to keep their spirits up.

At the end of World War II, the camp received and processed about 300,000 soldiers returning home. Kilmer's war duties were officially over by 1949. A few years earlier, in December 1947, the USO clubs had been closed. Having accomplished their wartime mandate to support the military

by providing a "home away from home," they were given an honorable discharge by President Truman. The need for the USO continued in subsequent conflicts, and the organization was reactivated in 1951 to meet the needs of the military during the Korean War. Whenever the military is involved, the USO is not far behind, offering support. Even today, the organization continues to operate, spurred on by the generous volunteerism of members throughout the United States.

GARDEN STATE ROSIES

WOMEN IN THE DEFENSE INDUSTRY

In some respects, women workers are superior to men. Properly hired, properly trained, properly handled, new women employees are splendidly efficient workers. The desire of a new woman worker to help win the war—to shorten it even by a minute—gives her an enthusiasm that more than offsets industrial inexperience.
—United States War Department

The War Department must fully utilize, immediately and effectively, the largest and potentially the finest single source of labor available today—the vast reserve of woman power.
—Henry L. Stimson, U.S. secretary of war

Preparing American society to accept women in defense industry roles was no small task. As with the iconic image of Uncle Sam, a fictional character emerged to help. Her name was Rosie the Riveter. Inspired by a song written by the Four Vagabonds, Rosie was everything the idealized female war worker was supposed to be. Patriotic, efficient and responsible, Rosie jumped into popular culture with a painting by Norman Rockwell that graced the front page of the *Saturday Evening Post* on May 29, 1943. Of course, this first rendition was very different than the poster many became familiar with. In Rockwell's version, Rosie was rough and muscular, posed with her lunch pail and rivet gun. If you looked closely, you could see a copy of Hitler's autobiography Mein Kampf squashed underneath her feet. A few months later, Rosie received a makeover. Another artist, Howard Miller, painted a much different rendition of the character. Miller's version was far

more feminine with less muscle and more makeup. Along with the famous slogan "We can do it!" this version of Rosie became synonymous with female workers during World War II.

The urgency of filling civil defense jobs was clear early on for many political leaders, especially President Roosevelt. In a message to Congress on May 16, 1940, Roosevelt advised:

> *These are ominous days—days whose swift and shocking developments force every neutral nation to look to its defenses in the light of new factors. The brutal force of modern offensive war has been loosed in all its horror. New powers of destruction, incredibly swift and deadly, have been developed; and those who wield them are ruthless and daring. No old defense is so strong that it requires no further strengthening and no attack is so unlikely or impossible that it may be ignored.*

With the increasing need for able-bodied men for combat, the task to keep the war industry running inevitably fell on American women. Posters asked women to "Do the job he left behind." New Jersey's already existing factories made the state a hub of production during World War II. While the iconic Rosie the Riveter is still one of the most recognized images concerning civil defense during World War II, the real-life women who worked for the war effort in New Jersey were a much more diverse group. The Garden State definitely had its share of "Rosies," but women also worked in many other capacities. Whatever the job, women throughout the state answered the call for wartime production with enthusiasm.

Who were these Garden State Rosies? Where did they work? What kind of jobs did they do? One of the largest production efforts in New Jersey was the conversion of the General Motors plants. The attack on Pearl Harbor effectively stopped the production of automobiles for consumer use. Seemingly overnight, General Motors shifted from making automobiles for consumers to assembling planes for the war effort. The Eastern Aircraft Division of General Motors was made up of facilities located in Linden, Trenton and Bloomfield, New Jersey, along with plants in Tarrytown, New York, and Baltimore, Maryland. With wartime navy contracts, the Linden facility transferred its efforts into making Wildcat fighters, and the Trenton-Ternstedt hardware plant focused on Avenger three-man torpedo-bombers. The Delco-Remy Battery plant in Bloomfield converted to making the wires, cables, hydraulic assemblies, electrical assemblies, ammunition boxes and decals for the planes. With these new demands, the recruitment of women was essential for

A two-star mother from Newark, New Jersey, works in a machine shop during World War II. *Joseph G. Bilby.*

success. Advertisements for the Eastern Aircraft Division appeared in local newspapers and called on women workers in 1943: "There are clean, simple, well-paid jobs waiting for women at Eastern Aircraft…You do not need any previous experience as you will be trained in work for which you are best fitted in the plant…So don't just wish you could take a broom to Hitler—take a job and really get in some good wallops." With the help of these new female workers, the plant in Linden turned out FM-1 and FM-2 Wildcats at an impressive pace. The Avengers were so complex that different pieces were assembled off site and transported to the Trenton plant to be finished. The partnership between

Grumman and the Eastern Aircraft Division manufactured about thirty-five thousand completed planes for the war effort.

The history of Garden State Rosies is as unique and complex as the women involved. The story of wartime participation on the homefront is often the story of entire families doing their part for victory. New Jersey veteran Nicholas Rakoncza served in the navy during World War II. Both of his parents (Annie and Nicholas) worked for the Eastern Aircraft Division of General Motors in Linden, New Jersey. Nicholas was the foreman on the fuselage line, and his wife, Annie, was a riveter's bucker on the same line. Years later, their son joked, "She wasn't Annie the riveter, she was Annie the bucker." The bucker's job was far from easy and required enough force to flatten the end of the rivet and clamp the pieces together tightly. Nicholas recalled, "The riveter and the bucker had to be in tune." When asked about the acceptance of women in the war effort, he said, "They got a lot of hard times from the men." In the face of such adversity, women like Annie proved those who doubted the abilities of women wrong. Their efforts in the civil defense industry were invaluable to the Allied victory.

Barbara Waters Kramer was a public relations worker at Eastern Aircraft. While at the factory, one of her main tasks was publishing a monthly newspaper about the plant. She gained a great deal of knowledge about the workers, often interviewing the pilots who tested the planes. Through many interviews, she noticed that the factory seemed to be the first job for many of the women. She said, "Yes, I'd say the majority were married women. I know one of my neighbors, who'd never worked before, went in. The women did really good." Kathryn Barber De Mott, who grew up in Clinton, New Jersey, was a draftsperson at the Eastern Aircraft Company. The need for people with technical knowledge led Rutgers to design a junior engineering course to prepare women to take on the roles of the men who left for combat. Kathryn enrolled in the difficult course, which ran five days per week from 8:00 a.m. to 5:00 p.m. for several months. She was one of about twenty-five young women who took the course. She worked at Eastern for about one year. Once the war ended, she was without a job. She said, "Now, at the end of the war, which was 1946, the plant shut down like that. We went in one morning and they said, 'We're closing down today. Yes, today. Take all your things and go.'" It was a bittersweet time for many women. While the end of the war brought relief, it also caused the removal of many women from jobs that were no longer essential.

After the war, the employees of the Eastern Aircraft Division received the Army-Navy "E" Award for high achievement. This honor was presented to a select number of factories that displayed outstanding wartime production.

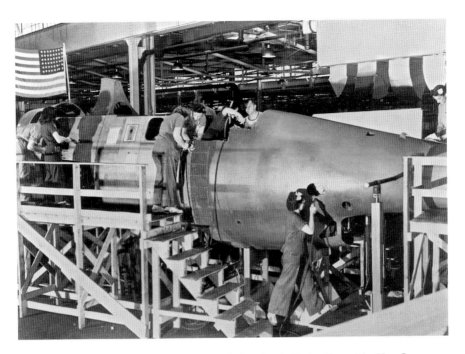

Women working as riveters assemble a torpedo bomber in Ewing Township, New Jersey. *Joseph G. Bilby.*

The criteria for this award included avoiding any production stoppages, low employee absenteeism and good accident and safety records. Along with commendations, the award included a flag to be flown at the plant, a certificate of appreciation and a lapel pin for all employees.

Other women did their bit for the war effort on assembly lines in glass factories. In Millville, a name still synonymous with glassmaking in the Garden State, women worked to ensure that bottles for blood plasma and water were ready to send out. The history of glass works in South Jersey began rather early. In 1806, James Lee started a glass factory in Millville. At the time, his was only the fourth such factory in the entire state. Lee's factory made window glass, bottles, pitchers, jars and other household items. The factory began producing insulators in the 1920s. In 1888, local pharmacist Dr. Theodore C. Wheaton made his own glass bottles for pharmaceutical products. Eventually, this small operation turned into a rather large one. The glass business continued to grow in the following decades. In 1969, Wheaton's grandson, Frank H. Wheaton Jr., opened a replica town to attract tourism. The attraction worked as countless schoolchildren, history buffs and local artists passed through historic Wheaton Village over the years. As with other industries in New Jersey, the coming of

Women work at Wheaton Village in Millville, New Jersey. *Wheaton Village.*

World War II led to a shift in priorities for glassmaking in Millville. Wheaton turned out several products necessary for the war effort, such as blood plasma bottles and containers used to purify water.

Ordnance Workers

The dangers present during wartime were not only limited to combat. Homefront injuries and deaths occurred, especially in factories that produced explosives. On a seemingly quiet afternoon on September 12, 1940, three fierce explosions rocked the Hercules Powder Company in Kenvil, New Jersey. The deafening blasts were so powerful that reports insisted that residents felt them up to seventy miles away. Windows shattered and shockwaves were felt by unsuspecting residents. In homes, dishes rattled and various items fell off shelves in tremors reminiscent of an earthquake. Once the chaos subsided, the true magnitude of the tragedy began to sink

in for locals. Over fifty plant employees lost their lives and more than one hundred were injured in varying degrees. With citizens already fearful of Axis infiltration into American society, the explosions triggered rumors of Nazi sabotage. Immediately after the incident, investigators were not eager to disregard that possibility either. The existence of a German American Bund Camp, whose members were sympathetic to the Nazi party, did not help to quell fears. Local newspapers joined in on the panic with headlines like "50 Killed in New Jersey Blast: Probe Hints of Sabotage" and "Hercules Blasts had been Plotted by Nazis." However, with the help of the FBI, an investigation eventually revealed that the real culprit was the volatile nature of the smokeless powder being used in the factory. The company's original purpose was to make dynamite for use in local mines. Once the United States entered World War II, the plant was utilized for the production of military ordnances. New Jersey women joined the ranks of the plant to ensure that wartime production goals were met. They worked with the explosive powder right alongside the men.

Sadly, this instance was not the only tragedy faced by wartime workers in the Garden State. The origin of the Congoleum plant in Kearny, New Jersey, dates back to the late nineteenth century. In 1886, the Scotland-based company began purchasing acreage in New Jersey. Originally, the

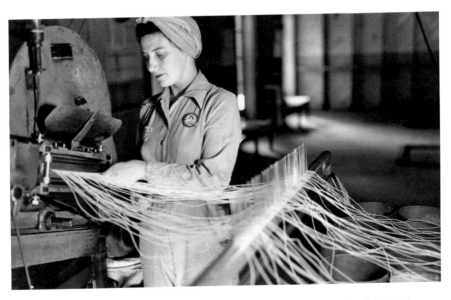

A woman working for the Hercules Powder Company cuts the strands of .50-caliber gun powder from the press. *Records and Ephemera of Hercules Inc. Chemical Heritage Foundation Archives.*

factory produced flooring. The plant's wartime production was truly varied, with grenades, cloth for tents, torpedo components and linoleum for war purposes produced. On the fateful day of August 19, 1943, another accidental explosion rocked the Congoleum-Nairn plant. That evening, a deafening blast went off a little after 5:00 p.m., followed shortly by the blaring of sirens. The explosion was felt miles away from the origin. The windows on buildings near the plant were shattered, and nearby homes shook. Police, emergency medical technicians and firefighters raced to the scene. Crowds of people appeared, some merely curious, others desperate to see if their loved ones were all right. After the smoke cleared, family members of the workers on shift rushed to the hospital to wait for news. Emergency responders from nearby towns joined in to help search the rubble for survivors. Tragically, thirteen workers were killed and many others were injured because of the blast. As with the Hercules explosion, rumors of sabotage circulated but were later dismissed.

Local arsenals were another major employer of women during World War II. The Raritan Arsenal in Edison, New Jersey, used women in a variety of jobs from ordnance work to clerical duties. An article asking for more men and women to

Worried relatives gather outside the Harrison Hospital after the Congoleum Factory explosion in Kearny, New Jersey. *Joseph G. Bilby.*

work at the arsenal read, "The trial period [during] which women were brought in to do the less arduous jobs left vacant by the men was so successful that women labor will be a permanent fixture at the Arsenal, at least for the duration." Women Ordnance Workers (WOW) also worked at the Picatinny Arsenal in Morris County, New Jersey. Originally called the Dover Powder Depot, the site was founded in 1880. The army renamed the site the Picatinny Arsenal in 1907. The plant focused on testing and research activities during World War I. Once the United States entered into World War II, the arsenal pulled back its research and refocused on wartime production. About eighteen thousand people were employed and worked three different shifts making bombs and shells. Many of the jobs women did at the arsenal were labor intensive and required special skills. Female workers used chamber gauges to check the alignment of cartridges, broke up nitrocellulose blocks by hand, inspected components, packaged bullets to be shipped out, welded parts, unloaded trucks, used pallet jacks, operated forklifts and worked in the laboratory.

The DuPont Company, a fixture in New Jersey since its founding in 1917, played a central role in World War II production. Based in Carney's Point, New Jersey, the company's factory produced explosives, smokeless powder, grenades and more. Catherine Ballantine, another student at Douglass College, worked in the explosive rivet department at the DuPont factory. Virginia Boardman, of Penns Grove, New Jersey, worked in the library at the DuPont Company. During the war years, the DuPont plant was making artificial vitamin D for chickens. Boardman's background education in chemistry made her an ideal candidate to work on this project.

OTHER WORKERS

The list of New Jersey businesses that contributed to the war effort in some way is truly impressive. Founded in 1873, the Singer Sewing Machine Manufacturing Company in Elizabeth, New Jersey, was a major operation even before the war. Originally occupying thirty-two acres of land, Singer made an impact on the local economy early on. During World War II, the company converted its operations into wartime production. Much like automobiles, sewing machines for consumer customers were hard to come by in the early 1940s. The Singer factory ceased production on sewing machines and made various armaments for military use, including wooden propellers, anti-aircraft guns and pistols.

A woman defense industry worker on the job in a propeller factory in Elizabeth, New Jersey. *Joseph G. Bilby.*

The General Ceramics and Steotite Corporation of Keasbey, New Jersey, received a War Department contract to make insulators. The Sigmund Eisner Company was a large-scale manufacturer of uniforms. With prominent customers like the New Jersey State Police and the Boy Scouts, it had plants in Red Bank, South Amboy, Long Branch and Freehold. During both world wars, Eisner made uniforms for the armed forces. In Atlantic City, Frank G. Seyfang's company, Seyfang Laboratories, made balloons used by radio stations to find new locations, in weather research and by the army and the navy.

In Freehold, New Jersey, the A&M Karagheusian Rug Mill made duck cloth, used by the military for tents, bags, gun covers and much more. Many women filled positions in this factory during the war. The Curtiss Wright Corporation was involved in the design and manufacture of planes for both military and commercial use. During World War II, the plant in Caldwell, New Jersey, manufactured airplane propellers. The plant was also instrumental in the war effort because of the production of

Ruth Moy, a war worker in a Paterson aircraft factory. *Joseph G. Bilby.*

planes, such as the P40 War Hawk, the SB2C Helldiver Navy Bomber and the Army A25 Helldiver. Women played an essential role in fulfilling the orders during wartime.

In Neptune City, the Mirabelli Company made clothes for the armed forces. Producing around $10 million of war clothing, the plants in Neptune City and Elizabeth provided much-needed uniforms for soldiers.

Of course, Roosevelt's famous Arsenal of Democracy speech called for more than just planes. Ships were also needed and in great quantity. The New York Ship Yard was on the forefront of New Jersey's efforts in this area. The company's name was somewhat misleading since it was actually located in Camden, New Jersey. Founded by Henry Morse in 1898, the company

eventually became one of the largest shipbuilding factories in the world. In the Camden community, it grew to encompass more area and eventually included housing for employees. During World War II, the factory employed around thirty thousand workers, both men and women.

New Jersey's college women were a welcome source of defense industry workers. Jean Comeforo of Metuchen, New Jersey, worked at the Johnson and Johnson factory during the war. Located in New Brunswick, New Jersey, the company converted to wartime production by making much-needed medical supplies for the war effort. Because Jean was a student at Rutgers, she worked at the factory a few days every week. She recalled, "I think it was three times a week, and it was for the war effort and so we made a little bit of money, pocket change really, but you were doing something positive for the war effort."

Aside from factory work, civilian women also worked at military bases. Judith Harper Hassert, a Highland Park, New Jersey native, worked as a librarian at Camp Kilmer. Since the camp was an embarkation base, there was always a large influx of new soldiers coming in. Judith worked in the hospital library, delivering books to and from the wards via book cart. She provided moral support along with the reading material she distributed. The hospital at Camp Kilmer kept soldiers with varying degrees of injuries. For those who had limited mobility, Judith's visits were a welcome break.

With the end of the war, many employees, including a substantial amount of women, were phased out. With the end of wartime contracts, companies were forced to terminate employees and reduce their staff to prewar levels. Many workers simply received letters like this one from the National Fireworks Company in Mays Landing, New Jersey: "I know that you will rejoice with all the United States in the fact that the war is over and I wish to take this opportunity to thank you in behalf of the National Fireworks, Inc. and the war department in your efforts at this Plant in making the end of the war possible." The impact of women entering into wartime jobs changed society and the women themselves. Truly, some women did simply return to the lives they led before the war turned everything upside down. However, the taste of independence felt during wartime work left many with a desire to continue after the Allied victory. For some women, defense industry work allowed them to earn their first paychecks and gave them the freedom to choose what they bought for the very first time. Some women were not willing to give up this new sense of independence.

EPILOGUE

V-E Day in New York City was just unbelievable. Everybody went out on the street, and we danced on the street. I remember being lifted up by the sailors and jumping around and hugging everybody: everybody was happy.
—Marie Griffin

The war years were a difficult time for many. Loved ones left for combat, families were separated and food and goods were in short supply. However, out of adversity, new opportunities, although still restrictive, opened for women and minorities. According to Pearl Patterson Thompson, as a woman, "you could only look forward to, four or five possibilities, secretary, teacher, nurse, librarian, dieticians, that sort of thing. There weren't many opportunities for women until the war came along, which broke it wide open…Then they got opportunities which they hadn't really had before, so, in that respect, it did them good." The war truly did open doors previously closed to women. Over and over again, they proved that they could take military discipline, serve in overseas operations and perform jobs that were physically demanding and technically challenging.

Politicians and military leaders alike viewed the wartime record of women with a mixture of respect and awe. In an address to Congress on April 16, 1945, a newly appointed President Truman spoke about the passing of Franklin Roosevelt and the road to victory. The solemn mood created by the passing of FDR did not dull Truman's sense of pride in the accomplishments of the nation's citizens. He said, "Our debt to the heroic men and valiant women in the service of our country can never be repaid. They have earned

our undying gratitude. America will never forget their sacrifices. Because of these sacrifices, the dawn of justice and freedom throughout the world slowly casts its gleam across the horizon." With the end of the war in sight, he vowed that the United States would accept nothing short of total victory against the Axis powers.

Truman's promise finally came to fruition on May 7, 1945, when Germany signed an unconditional surrender. The next day—forever celebrated as V-E Day, or Victory in Europe Day—news of the surrender hit the world. All across Great Britain, newly liberated Europe and America, people took to the streets in celebration, laughing and crying in joy. In New York City's Times Square, thousands gathered in a jubilant public display of victory. People embraced and cheered in the streets. In New Jersey, military camps and hospitals were focal points of jubilance. Residents of the Garden State spilled out onto the streets in communities small and large to congratulate each other. The idea that their loved ones would be coming home soon brought tears to the eyes of many. However, the fight was not over for everyone. The Pacific theater was still an active combat area. Finally, months later, the war was over on all fronts. On August 14, 1945, the announcement of the Japanese surrender reached the Allies.

When the dust finally settled, the world was never quite the same. As a watershed event in history, World War II altered society in ways that were truly amazing. The necessity of wartime created a need for women in areas that were viewed as socially unacceptable for them previously. Once the war ended, many wanted to return to a sense of normalcy. This meant that some women returned to their home lives or were married and started families of their own. However, some women, forever changed by their wartime experiences, could not simply return to their lives of dependency. Despite being thrown out of many wartime jobs to make room for the men who returned from the front lines, women were undeterred in their quest for postwar employment. Some continued their military or nursing careers. Others used the GI Bill to go to college. As military women and nurses, they risked their lives, and some paid the ultimate price for their country. Ultimately, the sacrifices made by these women, both on the homefront and overseas, will forever be remembered by future generations.

BIBLIOGRAPHY

ARTICLES

Caleo, Robert L. "From Autos to Aircraft: General Motors' WWII Conversion." *Naval Aviation News* (July–August 1995): 26–32.

Douglas, Deborah G. "United States Women in Aviation 1940–1985." *Smithsonian Studies in Air and Space*. Washington, D.C.: Smithsonian Institute Press, 1990.

Rasa, Mary, museum curator. "The Women of Fort Hancock." Gateway National Recreation Area, Sandy Hook. *Garden State Legacy* 23 (March 2014).

Stremlow, Mary V. "Free a Marine to Fight: Women Marines in World War II." *Marines in World War II Commemorative Series*. USMCR, 1994.

Thomson, Robin J. "The Coast Guard and the Women's Reserve in World War II." *Commandant's Bulletin*, October 1992.

Tilley, John A. "A History of Women in the Coast Guard." *Commandant's Bulletin*, March 1996.

Winchell, Megan K. "To Make the Boys Feel at Home: USO Senior Hostesses and Gendered Citizenship." *Frontiers* 25, no. 1 (2004): 190–211.

"World War II on the Homefront: Civic Responsibility." *Smithsonian in Your Classroom*, Fall 2007. Washington, D.C.: Smithsonian Center for Education and Museum Studies.

BOOKS

Bellafaire, Judith A. *The Women's Army Corps: A Commemoration of World War II Service*. Washington, D.C.: U.S. Army Center of Military History, 1993.

Bilby, Joseph G., James M. Madden and Harry Ziegler. *Hidden History of New Jersey at War*. Charleston, SC: The History Press, 2014.

BIBLIOGRAPHY

Carson, Julia M.H. *Home Away from Home: The Story of the USO.* New York: Harper & Brothers Publishing, 1946.

Coyne, Kevin. *Marching Home: To War and Back with the Men of Our American Town.* New York: Viking Penguin, 2003.

Eastern Aircraft Division. *A History of Eastern Aircraft Division General Motors Corporation.* Linden, NJ: Eastern Aircraft Division, 1944.

Feller, Carolyn M., and Deborah R. Cox, eds. *Highlights in the History of the Army Nurse Corps.* Washington, D.C.: U.S. Army Center of Military History, 2001.

Gabrielan, Randall. *Red Bank in the Twentieth Century.* Dover, NH: Arcadia, 1997.

Haydu, Bernice Falk. *Letters Home, 1944–1945: The Women Air Force Service Pilots.* Riviera Beach, FL: Topline Printing and Graphics, 2010.

Jones, John Bush. *The Songs That Fought the War: Popular Music and the Homefront, 1939–1945.* Lebanon, NH: Brandeis University Press, 2006.

Levinson, Dennis, ed. *Called to Duty: Recollections of Atlantic County Veterans.* Atlantic County Government, 2002.

Lurie, Maxine N., and Marc Mappen, eds. *Encyclopedia of New Jersey.* New Brunswick, NJ: Rutgers University Press, 2004.

Lyne, Mary C., and Kay Arthur. *Three Years Behind the Mast: The Story of the United States Coast Guard SPARs.* United States Coast Guard, 1946.

Monahan, Evelyn M., and Rosemary Neidel-Greenlee. *A Few Good Women: America's Military Women from World War I to the Wars in Iraq and Afghanistan.* New York: Anchor Books, 2010.

Morden, Bettie J. *The Women's Army Corps, 1945–1978.* Washington, D.C.: Center of Military History, United States Army, 2000.

Mullenbach, Cheryl. *Double Victory: How African American Women Broke Race and Gender Barriers to Help Win World War II.* Chicago: Chicago Review Press, 2013.

Roosevelt, Eleanor. *It's Up to the Women.* New York: Frederick A. Stokes Company, 1933.

Schrader, Helena Page. *Sisters in Arms: The Women Who Flew in World War II.* South Yorkshire, UK: Pen and Sword Aviation, 2006.

Stevens, Michael, ed. *Women Remember the War, 1941–1945 (Voices of the Wisconsin Past).* Madison: Wisconsin Historical Society Press, 1993.

Stremlow, Mary V. "Marine Corps Women's Reserve: Free a Man to Fight." In *In Defense of a Nation: Servicewomen in World War II.* Edited by Major General Jeanne M. Holm and Judith Bellafaire. Arlington, VA: Vandamere Press, 1998.

Taylor, Gay Lecleire. *The Fires Burn On: 200 Years of Glassmaking in Millville, New Jersey.* Museum of American Glass at Wheaton Village, 2006.

Weatherford, Doris. *American Women and World War II.* New York: Taylor & Francis, 2009.

Witt, Linda, Judith Bellafaire, Britta Granrud and Mary Jo Binker. *"A Defense Weapon Known to Be of Value" Servicewomen of the Korean War Era.* Hanover, NH: University Press of New England, 2005.

Yellin, Emily. *Our Mothers' War: American Women at Home and at the Front during World War II.* New York: Free Press, 2004.

Interviews

Haydu, Bernice. Interview by Patricia Chappine. Phone interview. October 14, 2014.

Rakoncza, Nicholas F. Interview by Patricia Chappine. In-person interview. Lakehurst, New Jersey. October 8, 2014.

Witt, Patricia. Interview by Patricia Chappine. In-person interview. Millville, New Jersey. September 28, 2014.

NEWSPAPER ARTICLES

Asbury Park Evening Press. "Karagheusian Mills Enlist for War, Make Miles of Duck Cloth for U.S." October 1, 1942.

Atlantic City Press. "Army Is Moving into Ambassador Hotel Tomorrow." June 29, 1942.

————. "City Blacks out for 35 Minutes in 'Secret' Drill." June 2, 1942.

————. "1000th Bed Lamp Presented to Hospital." March 1945.

————. "Resort to have Second USO Club." October 7, 1942.

————. "USO Offers New Service for Soldiers." November 28, 1943.

Brown, Irene C. "Balloons Made in Resort Used by Army and Navy." *Atlantic City Press*, February 10, 1946.

————. "Gray Ladies Heed Requests of Army Hospital Patients." *Atlantic City Press*, March 4, 1945.

Fifinella Gazette, March 1, 1943; April 23, 1943, 3; April 1, 1943, 2.

Fords Beacon. "Casualty Stations Organized." April 10, 1942.

————. "Keasbey Plant Receives Government Contract for Insulators." December 12, 1941.

————. "More Help Wanted at Raritan Arsenal." September 11, 1942.

————. "Nursery Furniture Needed at Kilmer." October 2, 1947.

————. "Red Cross Mobilized Promptly to Meet War Need." October 17, 1946.

————. "Red Cross Volunteers Vital Need" September 24, 1943.

————. "$3,000 Goal of Township USO; Brookfield Is Campaign Head." September 19, 1946.

Independent Leader. "Call Sounded for 'Gray Ladies' to Brighten Days for Soldiers." March 26, 1943.

————. "Gray Ladies Corps Recruits Are Sought." September 18, 1942.

————. "Motor Corps Class Starts." April 6, 1944.

————. "They Also Serve—Sixth of Series: Mrs. Ernest C. Burrows." March 3, 1944.

Layman, Theodore. "Army Dedicates Its Big Hospital at Atlantic City." *New York Herald Tribune*, Saturday, April 29, 1944.

Lewis, Ruth. "Goings On at the USO." *Red Bank Register*, January 6, 1944.

Matawan Journal. "Matawan Exceeds Quota in USO Drive." July 23, 1942.

————. "Red Cross Secures 135 Units of Blood Plasma at Second Bank in Area." December 3, 1942.

————. "WAVES Celebrate First Birthday." July 29, 1943.

New Era. "Red Cross Aids Service Men." March 2, 1944.

————. "Red Cross News." Thursday, January 6, 1944.

————. "WAC Drive." August 3, 1944.

BIBLIOGRAPHY

New York Times. "Set New Jersey Run of Air-Raid Kitchen." March 23, 1941.
———. "Women to Fight Fires Set by Bombs." May 3, 1941.
Rahway Record. "Cheerful Atmosphere at Camp Kilmer." January 27, 1944.
———. "Soldiers Look Forward to Rahway Night at Camp Kilmer Snac[k] Bar." January 27, 1944.
Red Bank Register. "Army Officer Praises Red Cross." March 15, 1945.
———. "Join Nurse Cadet Corps: Will Train at Englewood." February 3, 1944.
———. "Kitchen Soldiers." August 27, 1942.
———. "Local USO to Have Open House Program: Residents of This Vicinity Urged to Visit Clubhouse." February 3, 1944.
———. "Major MacKinlay Speaker at Rally of USO Hostesses." October 14, 1943.
———. "Many Services Offered by USO to Servicemen." June 29, 1944.
———. "Marjorie Hill WAC Instructor." April 19, 1945.
———. "Seabee Expresses His Appreciation: Thanks Red Cross for Package." January 25, 1945.
———. "Soldier Writes Poem to Nurse." March 29, 1943.
———. "Special Jobs Open to WACs." February 17, 1944.
———. "To Recruit WACs for Service in Army Hospitals." January 25, 1945.
———. "USO Campaigns in Full Swing." May 22, 1942.
———. "USO Traveler's Aid Service Helps Many." August 12, 1943.
———. "WAC Needs 2,212 for All-Jersey Company." November 4, 1943.
———. "WAC Offers Women Jobs in Many Fields." October 28, 1943.
———. "WACs Become Part of U.S. Army." July 8, 1943.
———. "WACs Have Equal Rights with Soldiers." July 8, 1943.
———. "WAC Supply Officer on the Double." April 27, 1944.
———. "WACs Wanted for Air Forces Work." November 4, 1943.
Review: Thomas M. England General Hospital Paper. "Red Cross Staff, Aides, Volunteer Duties Varied." March 14, 1946.
Signal Corps Message. "Red Cross Women Perform Heroic Task in Emergency." February 25, 1944.
South Amboy Citizen. "Advertisement for the Eastern Aircraft Factory." January 8, 1943.
———. "Hoffman High School Junior Red Cross Reports on Work of Past Year." January 1, 1943.
Township Tattle. "AWVS of Milburn." April 1945.
Westfield Leader. "USO Activity Enters New Phase." September 20, 1945.
———. "USO Sponsoring 'Hometown List' for Soldiers' Use." August 27, 1942.

Magazine Articles

"Civilian Defense: The Ladies!" *Time Magazine*, January 26, 1942.
"Hobby's Army." *Time Magazine*, January 17, 1944.
Roosevelt, Eleanor. "If You Ask Me." *Ladies' Home Journal*, May 1941. http://www.gwu.edu/~erpapers/IYAM/November1941.html (accessed December 20, 2014).
———. "If You Ask Me." *Ladies' Home Journal*, July 1942. http://www.gwu.edu/~erpapers/IYAM/July1942.html (accessed June 10, 2014).

———. "If You Ask Me." *Ladies' Home Journal,* August 1943. http://www.gwu. edu/~erpapers/IYAM/August1943.html (accessed June 10, 2014).

Stevenson, Eleanor, and Pete Martin. "I Knew Your Soldier." *Saturday Evening Post,* October 28, 1944.

"Toughening Up the Women Marines." *NY Times Magazine,* June 20, 1943: 12–13.

Woolley, Martha S., and Pete Martin. "Camp Boardwalk." *Saturday Evening Post,* February 27, 1943: 26.

MEMORANDA, PAMPHLETS AND LETTERS

American Women's Voluntary Services: Atlantic County Unit, letter to members, February 15, 1945.

Atlantic City Board of Trade: Victory Edition, August 17, 1942.

Bishop, John W. Letter to the AWVS of Atlantic City, January 11, 1944.

Cadet Nurse Corps. Recruitment Brochure. "Enlist in a Proud Profession." Jackson Library, University of North Carolina at Greensboro, 1943.

Cochran, Jacqueline to Sadie Johnson. August 19, 1943. National Archives at College Park, MD. Records Group 18, Entry 190, Box 918.

Conroy, E.J. to Anna M. MacPherson. National Fireworks, Inc. August 18, 1945.

Eastern Aircraft Division of General Motors in Linden, NJ, Army-Navy "E" Award for High Achievement, November 8, 1944.

Gustafson, Elaine Shaner. "Brief History of AWVS American Women's Voluntary Services Atlantic Unit during the War Years and through 1948 in Atlantic County." 1984.

"List of Organizations Supporting the Camp and Hospital Committee of the Atlantic County, New Jersey Chapter, American Red Cross in a Financial Matter." July 18, 1946.

McGuire-Dix-Lakehurst. *Joint Base Guide.* San Diego, CA: MARCOA Publishing, 2014.

Neptune City in World War II: A Report to the Citizens of Neptune City, N.J. Neptune, NJ: Local Defense Council, 1944.

Public Relations Division for the Women's Reserve Division U.S. Coast Guard. *A Preliminary Survey of the Development of the Women's Reserve of the United States Coast Guard.* Washington, D.C.: U.S. Coast Guard, April 1, 1945.

Seemeller, Carlette S. to parents. August 31, 1944.

Smith, Betty. "There Are a Thousand Ways You Can Help." *National AWVS Bulletin,* June–July 1944, 3.

Stimson, Henry L. "You're Going to Employ Women." Washington, D.C.: U.S. War Department, April 1, 1943.

Thomas England General Hospital Brochure. "Dedicatory Exercises." April 28, 1944.

USO Hail and Farewell. Women's Division of the National Catholic Community Service of Atlantic City, January 5, 1943–July 31, 1946.

USO Volunteer Handbook. Arlington, VA, July 2011.

BIBLIOGRAPHY

SPEECHES

Roosevelt, Franklin Delano. "Day of Infamy" Speech. December 8, 1941; SEN 77A-H1, Records of the United States Senate; Record Group 46; National Archives.

———. "Executive Order 9163: Establishing a Women's Army Auxiliary Corps and Providing for Its Organization." May 15, 1942. Online by Gerhard Peters and John T. Woolley. American Presidency Project. http://www.presidency.ucsb.edu/ws/?pid=60953 (accessed January 3, 2015).

———. "Fireside Chat 23." October 12, 1942.

———. "Message to Congress on Appropriations for National Defense." May 16, 1940.

———. "Proclamation 2425: Selective Service Registration." September 16, 1940. Online by Gerhard Peters and John T. Woolley. American Presidency Project. http://www.presidency.ucsb.edu/ws/?pid=15858.

———. "Statement on the First Anniversary of the WAVES." July 30, 1943. Online by Gerhard Peters and John T. Woolley. American Presidency Project. http://www.presidency.ucsb.edu/ws/?pid=16438 (accessed January 14, 2015).

———. "Statement Opening the Red Cross Fund Drive." February 28, 1943. Online by Gerhard Peters and John T. Woolley. American Presidency Project. http://www.presidency.ucsb.edu/ws/?pid=16370 (accessed January 3, 2015).

Truman, Harry S. "Address Before a Joint Session of Congress, April 16, 1945." Harry S. Truman Library and Museum. http://www.trumanlibrary.org/ww2/stofunio.htm (accessed January 22, 2015).

———. "Radio Address Opening the Annual Campaigns for the Community Chest and the United Service Organizations, October 1, 1946." Public Papers of the Presidents: Harry S. Truman. http://www.trumanlibrary.org/publicpapers/index.php?pid=1761 (accessed November 14, 2014).

RECORDS

U.S. House of Representatives. *Bill Establishing the WAC.* HR 77A-B5. 77th Cong., 2d. *Congressional Record* 145, no. 158 (December 30, 1941): H11916-H11921.

WEBSITES

British Air Transport Auxiliary. "ATA History." http://www.airtransportaux.com/.

Congoleum. "History and Heritage." http://www.congoleum.com/history_and_heritage.php.

Daily Journal. "World War II History: Millville USO." http://www.thedailyjournal.com/article/20090403/NEWS01/90406031.

Destroyer History Foundation. "New York Shipbuilding." http://destroyerhistory.org/destroyers/newyorkship/.

Maidenhead Heritage Center. "About the Air Transport Auxiliary." http://www.atamuseum.org/about-the-ata/.

BIBLIOGRAPHY

Myers, Jessica. "The Navy's History of Making Waves." Department of the Navy. http://www.navy.mil/submit/display.asp?story_id=75662.

National Archives and Records at New York City. "Camp Kilmer." http://www.archives.gov/nyc/exhibit/camp-kilmer/.

National Women's History Museum: Partners in Winning the War. "American Women in World War II." https://www.nwhm.org/online-exhibits/partners/32.htm 2007.

National World War II Museum: New Orleans. "By the Numbers: The U.S. Military." http://www.nationalww2museum.org/learn/education/for-students/ww2-history/ww2-by-the-numbers/us-military.html.

Navy History. "Navy Commissions First Black Female Officers, 26 December 1944." http://www.history.navy.mil/vignettes/women/FirstAAFemale.htm.

New Jersey Digital Highway. "Camp Kilmer USO Hostesses of World War II." http://www.njdigitalhighway.org/enj/lessons/ww_ii_and_nj/?part=camp_kilmer_uso.

———. "The WAC Overseas." http://www.njdigitalhighway.org/enj/lessons/ww_ii_and_nj/?part=women_army_corps_overseas.

Paterson Friends of the Great Falls. "History." http://patersongreatfalls.org/otherindustries.html.

Picatinny Arsenal. "Picatinny Arsenal Historical Overview." http://www.pica.army.mil/PicatinnyPublic/about/history.asp.

Red Cross History. "A Brief History of the American Red Cross." http://www.redcross.org/about-us/history.

Roosevelt, Eleanor. "My Day Column." George Washington University: Eleanor Roosevelt Papers Project. September 1, 1942. http://www.gwu.edu/~erpapers/myday/displaydoc.cfm?_y=1942&_f=md056279.

———. "Women in War." PBS. http://www.pbs.org/wgbh/americanexperience/features/primary-resources/eleanor-women/.

Shea, Patrick. "Boom Times." *Chemical Heritage Magazine*, Summer 2013. http://www.chemheritage.org/discover/media/magazine/articles/31-2-boom-times.aspx?page=3.

Singer Sewing Company. "Singer Factories—Elizabeth Port, New Jersey." http://www.singersewinginfo.co.uk/elizabethport/.

U.S. Army Signal Corps. "A History of Fort Monmouth New Jersey, 1917–1946." http://www.archive.org/details/HistoryOfFortMonmouthNewJersey1917-1946.

Watson, Susan. "Red Cross Retrospective: The Gray Lady Service." American Red Cross. http://www.redcross.org/news/article/Red-Cross-Retrospective-The-Gray-Lady-Service.

Women in the U.S. Army. "Women's Army Auxiliary Corps." http://www.army.mil/women/history/wac.html.

Zautyk, Karen. "Dark Day in Kearny History." *Observer*, August 21, 2013. http://www.theobserver.com/?p=16427.

BIBLIOGRAPHY

ORAL HISTORY ARCHIVES

Archibald, Alice Jennings. Oral history interview by G. Kurt Piehler and Eve Snyder. March 14, 1997. Rutgers Oral History Archives 7, 10, 20. http://oralhistory.rutgers.edu/social-and-cultural-history/31-interviewees/750-archibald-alice-jennings.

Ballantine, Catherine. Oral history interview by Tara Kraenzlin and Michael Bino. March 2, 1999. Rutgers Oral History Archives 12, 13, 17. http://oralhistory.rutgers.edu/social-and-cultural-history/31-interviewees/775-ballantine-catherine.

Boardman, Virginia, Oral history interview by Tara Kraenzlin and Laura Vallence. March 25, 1999. Rutgers Oral History Archives 6, 7, 18. http://oralhistory.rutgers.edu/social-and-cultural-history/31-interviewees/813-boardman-virginia.

Busch, Mary Lou Norton. Oral history interview by Shaun Illingworth, Matthew Lawrence and Jessica Thomson Illingworth. August 17, 2007. Rutgers Oral History Archives 9, 16. http://oralhistory.rutgers.edu/social-and-cultural-history/31-interviewees/837-busch-mary-lou-norton.

Comeforo, Jean C. Oral history interview by G. Kurt Piehler, Maria Mazzone and Melanie Cooper. April 10, 1996. Rutgers Oral History Archives 19, 20, 21. http://oralhistory.rutgers.edu/social-and-cultural-history/31-interviewees/868-comeforo-jean-c.

De Mott, Kathryn Barber. Oral history interview by Sandra Stewart Holyoak and Jared Kosch. June 9, 2003. Rutgers Oral History Archives 14, 16. http://oralhistory.rutgers.edu/social-and-cultural-history/31-interviewees/879-de-mott-kathryn-barber.

Dodd, Rosemarie Spagnola. Oral history interview. Rosemarie Dodd Collection (WV00020), Betty H. Carter Women Veterans Historical Project, Martha Hodges Special Collections and University Archives, University Libraries, University of North Carolina at Greensboro, NC.

Edwards, Marjorie Randolph Suggs. Oral history interview. Marjorie Randolph Suggs Edwards Papers (WV0177), Betty H. Carter Women Veterans Historical Project, Martha Hodges Special Collections and University Archives, University Libraries, University of North Carolina at Greensboro, NC.

Godfrey, Nancy Petersen. Oral history interview by G. Kurt Piehler and Barbara Tomblin. February 14, 1997. Rutgers Oral History Archives 45, 46. http://oralhistory.rutgers.edu/social-and-cultural-history/31-interviewees/941-godfrey-nancy-petersen.

Griffin, Marie. Oral history interview by Kathleen Plunkett. March 16, 1996. Rutgers Oral History Archives 8. http://oralhistory.rutgers.edu/social-and-cultural-history/31-interviewees/959-griffin-marie.

Hassert, Judith Harper. Oral history interview by G. Kurt Piehler and Barbara Tomblin. February 4, 1997. Rutgers Oral History Archives 45, 46. http://oralhistory.rutgers.edu/social-and-cultural-history/31-interviewees/975-hassert-judith-harper.

Heckendorn, Mary Ellershaw. Phone interview by Tom Hanley. WAC Sandy Hook, Gateway NRA, NPS. March 9, 2004. Transcribed by Mary Rasa, 2010.

BIBLIOGRAPHY

Hickcox, Elizabeth C. Oral history interview. Elizabeth C. Hickcox Papers (WV0067), Betty H. Carter Women Veterans Historical Project, Martha Hodges Special Collections and University Archives, University Libraries, University of North Carolina at Greensboro, NC.

Higgins, Joan Yunker. Oral history interview by Shaun Illingworth and Matthew Lawrence. April 26, 2007, Rutgers Oral History Archives 22. http://oralhistory.rutgers.edu/social-and-cultural-history/31-interviewees/979-higgins-joan-yunker.

Kamich, Ida Perlmutter. Oral history interview by Sandra Stewart Holyoak, Mallory Reichert and Rachel Marcus. April 22, 2005. Rutgers Oral History Archives 1, 2. http://oralhistory.rutgers.edu/interviewees/1017-kamich-ida-perlmutter.

Karesh, Janice. Oral history interview by Sean Harvey and Sandra Stewart Holyoak. June 2, 2000. Rutgers Oral History Archives 16. http://oralhistory.rutgers.edu/social-and-cultural-history/31-interviewees/1019-karesh-janice.

Kramer, Barbara Waters. Oral history interview by G. Kurt Piehler and Donovan Bezer. March 23, 1998. Rutgers Oral History Archives 23, 24. http://oralhistory.rutgers.edu/social-and-cultural-history/31-interviewees/1045-kramer-barbara-waters.

Krugman, Marian. Oral history interview. Marian Gold Krugman Papers (WV0354), Betty H. Carter Women Veterans Historical Project, Martha Hodges Special Collections and University Archives, University Libraries, University of North Carolina at Greensboro, NC.

Lathrop, Olga Lewandowski. Oral history interview. Olga L. Lathrop Papers (WV0271), Betty H. Carter Women Veterans Historical Project, Martha Hodges Special Collections and University Archives, University Libraries, University of North Carolina at Greensboro, NC.

Levin, S. Carol. Oral history interview by Chris Hillary and Laura Micheletti. April 1, 1998. Rutgers Oral History Archives 18, 28. http://oralhistory.rutgers.edu/social-and-cultural-history/31-interviewees/1067-levin-s-carol.

McClure, Bertha Nichols. Oral history interview. Bertha Nichols McClure Papers (WV0478), Betty H. Carter Women Veterans Historical Project, Martha Hodges Special Collections and University Archives, University Libraries, University of North Carolina at Greensboro, NC.

McIntyre, Jessie Watt. Oral history interview. Jessie E. McIntyre Papers (WV0237), Betty H. Carter Women Veterans Historical Project, Martha Hodges Special Collections and University Archives, University Libraries, University of North Carolina at Greensboro, NC.

Moncrief, Ruth Sheeler. Oral history interview by Sandra Stewart Holyoak, Sabeenah Arshad and Hanne Ala-Rami. October 5, 2007. Rutgers Oral History Archives 29. http://oralhistory.rutgers.edu/social-and-cultural-history/31-interviewees/1123-moncrief-ruth-sheeler.

Moon, June McCormack. Oral history interview by Sandra Stewart Holyoak and Eliza Davino. October 20, 2003. Rutgers Oral History Archives 4. http://oralhistory.rutgers.edu/social-and-cultural-history/31-interviewees/1126-moon-june-mccormack.

BIBLIOGRAPHY

Newby, Edna M. Oral history interview by G. Kurt Piehler and Barbara Tomblin. February 21, 1997. Rutgers Oral History Archives 33. http://oralhistory.rutgers. edu/social-and-cultural-history/31-interviewees/1140-newby-edna.

Robinson, Mary. Oral history interview by G. Kurt Piehler, Linda Lasko and Bruce Chadwick. October 28, 1994. Rutgers Oral History Archives 19, 23. http:// oralhistory.rutgers.edu/social-and-cultural-history/31-interviewees/1202-robinson-mary.

Sheehan, Jean O'Grady. Oral history interview by Sandra Stewart Holyoak. September 21, 2006. Rutgers Oral History Archives 22, 27. http://oralhistory.rutgers.edu/social-and-cultural-history/31-interviewees/1240-sheehan-jean-ogrady.

Thompson, Pearl Paterson. Oral history interview by Greg Kupsky. December 18, 2001. Rutgers Oral History Archives 12, 13. http://oralhistory.rutgers.edu/social-and-cultural-history/31-interviewees/1288-thompson-pearl-paterson.

Wakefield, Kathryn Fulner. Oral history interview. Kathryn F. Wakefield Papers (WV0275), Betty H. Carter Women Veterans Historical Project, Martha Hodges Special Collections and University Archives, University Libraries, University of North Carolina at Greensboro, NC.

Waugh, Margaret Harriet. Oral history interview by Laura Micheletti and Barbara Tomblin. January 28, 1999. Rutgers Oral History Archives 12, 14, 30, 35, 36. http://oralhistory.rutgers.edu/social-and-cultural-history/31-interviewees/1312-waugh-margaret-harriet.

Weir, Annis. Oral history interview. Annis Glendon Weir Papers (WV0148), Betty H. Carter Women Veterans Historical Project, Martha Hodges Special Collections and University Archives, University Libraries, University of North Carolina at Greensboro, NC.

Wilson, Edna Smith. Oral history interview. Edna Smith Wilson Papers (WV0355), Betty H. Carter Women Veterans Historical Project, Martha Hodges Special Collections and University Archives, University Libraries, University of North Carolina at Greensboro, NC.

INDEX

INDEX

INDEX

ABOUT THE AUTHOR

Patricia Chappine is an adjunct professor at Stockton University and Atlantic Cape Community College. She earned a bachelor's degree in sociology and a master's degree in Holocaust and genocide studies from the Richard Stockton College of New Jersey and is currently a doctoral student in the History and Culture Program at Drew University. She lives in Hammonton, New Jersey, with her husband, Ernie.